Selected by
Susan Hiller

Dream
Machines

National Touring Exhibitions

sbc

Published on the occasion
of *Dream Machines*,
a National Touring Exhibition
organised by the Hayward
Gallery, London, for the
Arts Council of England

Exhibition tour:
Dundee Contemporary Arts
5 February – 26 March 2000
Mappin Art Gallery, Sheffield
8 July – 20 August 2000
Camden Arts Centre, London
7 September – 29 October 2000

Director's Preface

Exhibitions selected by artists are an important element of the Hayward Gallery's National Touring Exhibitions programme, and have produced some of our most stimulating projects in recent years. Often impelled by ideas present in their own work, an artist's approach to selecting an exhibition inevitably reflects his or her particular way of seeing, and has the potential to share with the viewer a personal and intimate understanding of art.

Dream Machines has been selected by Susan Hiller, a highly influential figure in British art. The exhibition's focus on dreams and altered states of consciousness reflects ideas developed in her own work and is inspired too by the work of others. Presenting a wide variety of work in all media, she asks why it is that so many artists are interested in dreams and reverie. Her selection is international and cross-generational, mixing contemporary artists with some from earlier generations whose art has great resonance today.

Hiller's own work is poised between art's imaginative processes and 'rational', scientific explanations for unconscious or transcendental impulses. It involves the artist and viewer in an exploration of dreams, fantasy, paranormal phenomena and the realm of the irrational, and supremely qualifies Susan Hiller as a selector of a show which investigates these areas.

We are delighted that *Dream Machines* opens at the new Dundee Contemporary Arts, and are grateful to its Director, Andrew Nairne, and its Curator, Katrina Brown, for the commitment they have shown to the exhibition from an early stage. Julie Milne at the Mappin Art Gallery in Sheffield, and Jenni Lomax of Camden Arts Centre in London have also welcomed *Dream Machines* into their programmes with enthusiasm and energy.

We are similarly grateful to the many people whose expertise has helped to shape the exhibition, in particular Adrian Fogarty, who has co-ordinated the audio-visual and electronic elements, and to Guy Brett for helpful advice on sources. We thank Jean Fisher, whose essay in this publication discusses the nature of dreaming and the imagination with such insight and breadth of reference. Fiona Bradley, the Hayward's Exhibition Organiser responsible for this project, has with Susan Hiller contributed the notes on artists and works published here, and I thank her for this, as well as for her and Sophie Allen's attention to every aspect of the exhibition's preparation and delivery.

We extend our thanks also to Simon Esterson for his imaginative design of this catalogue and Kate Bell for overseeing its production. *Dream Machines* is an ambitious show, and we owe a great debt to Susan Hiller for her wholehearted engagement with it. Her idea has inspired a notably generous response from artists, and the exhibition has benefited enormously from their direct involvement. They have matched Susan's enthusiasm with their own, and confirmed her intuition that the worlds of dreams and altered states of consciousness are of particular interest and relevance to contemporary artists.

Not least, and as ever, we are grateful to the collectors whose collaboration and willingness to lend has made this exhibition possible.

Susan Ferleger Brades
Director, Hayward Gallery

Susan Hiller

Selector's Introduction

I'm interested in reverie, dreams, trance, hallucinations, spirituality, altered states of consciousness, psychological borderlands of all kinds – and so are a lot of other contemporary artists. For a long time I've imagined an exhibition that would focus on moments when artists share with other people their own experiences of the unstable zones where the visual merges with the visionary.

Dream Machines begins where we are now on the fluctuating cycle of attention Western art gives to the psychology of consciousness, mental states and the unconscious. This cycle of attention goes back at least as far as the Romantics, although of course philosophical debates about 'dream' and 'reality' are much, much older. *Dream Machines* starts to map a terrain by including artists from several generations, mixing contemporary art with earlier germinal works such as Brion Gysin and Ian Sommerville's experimental *Dreamachine* of 1960, a mobile low-tech construction designed to kick-start the visionary capacities of spectators; the hypnotic, incantatory sound poems of Kurt Schwitters from the 1920s; and Henri Michaux's intoxicating mescaline drawings of the 1950s.

Some of the works I've selected for the exhibition propose the possibility of shifting the viewer's consciousness through visual means to induce revelation, sudden multi-level insights, visions. Other works offer routes to unusual states of awareness by playing with words and breaking up language so that signifiers float free of their signifieds. Still others document the subjective experiences of artists who use themselves as the guinea-pigs or initiators of experiments, and seem to raise the question of whether (altered) states of consciousness and unconsciousness can be represented at all. And some of the works in *Dream Machines* take an ironic, even cynical approach to the whole realm of the irrational and uncanny; they can be very funny as well as enlightening. I've not selected any works that appropriate traditions like shamanism or visual styles from other cultures because these detours often lead to stereotypes and misunderstandings. Personally, I think we have enough

mysterious darkness within ourselves and our own culture to be getting on with. For similar reasons, I've excluded works that exoticize and freeze 'the unconscious', like the paintings by some surrealists which represent dream imagery as a static rebus decipherable by experts.

Instead of locating unconscious states of mind 'elsewhere', the works in *Dream Machines*, by many different methods, bridge a permeable border between two fragments of one and the same territory. For example, Lygia Clark's disturbing dream inspires a performance work for a number of participants, who experience *corpo coletivo* (collective body) which is 'the exchange between people of their intimate psychology'; André Masson produces drawings using the technique of 'pure psychic automatism', based on the mediumistic assumption that this process gives access to images and ideas which otherwise would remain out of sight; Alberto Giacometti's dream diagrams and text hover on the verge of announcing that neither form can satisfactorily represent certain areas of reality which are intrinsic parts of our experience; and Louise Bourgeois' insomniac drawings suggest that the artwork and the dreamwork may be interchangeable. These works revitalize connections to the unconscious components which are continuously present in every aspect of our lives. In this sense, all the artworks in this exhibition are bridges, elastic locations where we can communicate about the reality of certain specific sorts of unconsciousness. They let us practise and perfect our ability to travel.

Paying attention to such things, as I've said, comes and goes in Western art. In *Dream Machines,* echoes bounce back and forth across several artistic generations. And since art reflects (while reciprocally producing) facets of what goes on in the social sphere, we can assume that these specific sorts of unconsciousness are also relevant outside art from time to time. Right now there is a major resurgence of interest in the kinds of experiences that can be heightened through the use of music, meditation and certain chemical substances. Some individual

works in *Dream Machines* refer to the effects of narcotic or hallucinogenic drugs, but the exhibition as a whole doesn't advise people to ingest them. Our human brain is already an immensely complex chemical system demonstrating a more-or-less direct relationship between states of mind and particular chemical balances/imbalances. Psychoactive drugs alter the brain's 'normal' effects by changing the speeds and intensities by which it already operates, but they actually add no new ingredients to its chemical mix. This intriguing fact, it seems to me, is itself an aid in thinking about definitions of 'normal' and 'abnormal' perceptions, heightened or lowered awareness, reality and fantasy, consciousness and unconsciousness, being and nothingness, and what interests the artists in this exhibition.

We all experience altered states of consciousness nightly, without outside assistance. We don't need to absorb any chemical to begin to dream. And, unlike states of awareness attained through esoteric disciplines by study and technique, dreaming does not require us to learn anything special. Dreams dissolve and remix our waking thoughts, and are a universal exit from language and temporal succession. If you stop to think about dreaming, you may well find yourself in a vortex of philosophical paradoxes, enigmas and conundrums that will liquify any fixed notions of 'self' and 'reality'. That's why the word 'dream' is an important part of this exhibition's title.

I think *Dream Machines* is about more than my personal taste, although I like to look at, listen to, wonder about, dream on, and think about these artworks. The exhibition as a whole asks but doesn't answer the question of why some artists are interested in paying attention to certain conditions of consciousness and unconsciousness. Instead, it shows how artists explore and communicate an awareness perpetually relegated to the margins of social thought because it signals an epistemological upheaval… Illusion or delusion, genuine magic or sleight of hand, altered states of consciousness or a complete con? Why not try out the possibilities offered by these works before coming to your own conclusions?

Dream
Machines

Marina Abramovic
The Netherlands
born 1946, Yugoslavia

Untitled (Sodalite pillow)

1994
Sodalite, metal brackets,
wood box and lucite plaque
19 × 9 × 9 cm
Edition of 21
Courtesy Sean Kelly Gallery,
New York

Untitled (Smoked Quartz pillow)

1994
Smoked quartz, metal
brackets, wood box and
lucite plaque
19 × 12 × 12 cm
Edition of 11
Courtesy Sean Kelly Gallery,
New York

Shoes for Departure (Amethyst)
[illustrated]
1995
Amethyst
44 × 15 × 15 cm
© DACS, 2000

Marina Abramovic's crystal *Shoes for Departure* offer to transport the viewer into an altered state of consciousness. With the artist's written instructions functioning almost as a hypnotic suggestion, the shoes provide the means to enter a space of trance and contemplation: 'With naked feet enter the shoes.
Eyes closed.
Motionless.
Depart.
Duration: limitless
Material: amethyst'
The artist's mineral pillows encourage a similar journey into the unconscious, as viewers are invited by the artist to rest their heads on them and experience the mind-altering properties of the crystal supports: 'Smoked quartz, works on the subconscious going deep into the past of memory to balance the conscious mind'; 'Sodalite, amplifies dreams'. The works create their meaning in their interaction with the feelings and imaginations of an audience, and in the re-enacting and re-definition by that audience of states of mind suggested by the artist.

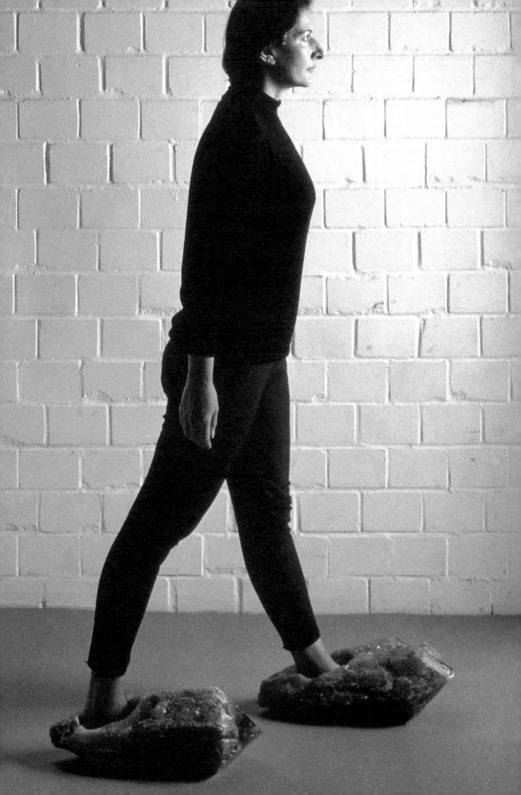

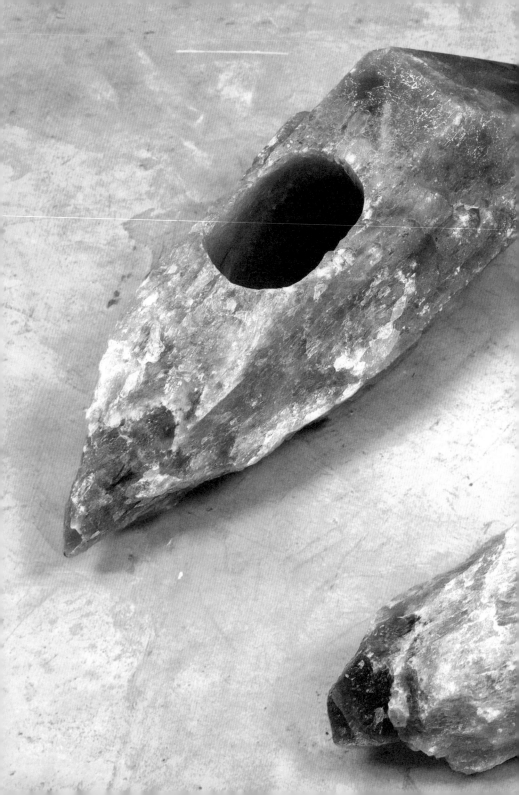

Francis Alÿs
Mexico
born 1959, Belgium

Narcotourism
1996
Photographs and printed
texts on paper
Three parts:
45 x 36 cm;
27.5 x 36 cm;
23 x 31.5 cm
Courtesy the artist
Photograph: Mike Fear

In this work Francis Alÿs is working with two kinds of displacement, geographical and mental, a combination he equates with the artistic process, observing that: 'As an artist, my position is akin to that of a passer-by trying to situate myself in a moving environment.' Approaching the problem of getting to 'know' Copenhagen, a foreign city, he orientates himself by imposing a set of rules: he will take seven walks in seven days, each under the influence of a different drug. In this way, the piece is about being physically present in a place while existing mentally somewhere else. Documenting the experience objectively – in photographs – as well as subjectively – by recording the feelings induced by each drug, the artist provides a series of overlapping mental and physical 'maps' obliquely referencing the city. 'My work is a succession of notes and guides. The invention of a language goes together with the invention of a city. Each of my interventions is another fragment of the story that I am inventing, of the city that I am mapping. In my city, everything is temporary.'

I met a man in C. who kept on inviting me
for another drink.
That man was me.

 Narcotourism,Copenhagen 1996

Francesco Bonami
& Hans-Ulrich Obrist
USA & France
born 1955, Italy
& 1968, Switzerland

Sogni/Dreams
1999
Book published by the
Fondazione Sandretto Re
Rebaudengo per l'Arte, Turin
Edition 50,000 copies
Distribution Project:
Venice Biennale 1999;
Dream Machines 2000

You are invited to take a complimentary copy of *Sogni/Dreams* home with you, as part of a distribution project curated by Francesco Bonami and Hans-Ulrich Obrist. The book is a collection of artists' dreams, published to celebrate the Fondazione Sandretto Re Rebaudengo per l'Arte's new building in Turin, and offered to readers free of charge.

In their preface, the organisers outline their aspirations for the project: 'We look back and forth swinging between nostalgia and science-fiction, only rarely do we think about our dreams as a necessary possibility for our present. *Sogni/Dreams* is a project that wants to dream about realizable and unrealizable dreams and make them real and possible.'

One hundred artists were invited to participate in the book. Each participant was asked 'to share with us one of their necessary dreams, ideas they would like to see become a reality while still alive to enjoy it'. In fact, very few of the invited artists used the concept of 'dream' to disclose a wish or hope for the future; mostly they offered personal dream narratives and images, making the book a window on to the unconscious sources of contemporary creativity.

Dream of being a snake

When I looked, I was a snake. Gazing around from a quite lower point of the bush, there was my friend, another snake (I am not sure about its sex), and the sun was shining around us. Anyway, I was sleepy. At this time, I found out for the first time how snakes could be so sleepy during the daytime.
While dozing, someone was rustling along the bush on the other side.
My snake friend cried to me. «Watch out, and run away!»
I thought that my friend must be a female, then.
At that moment, an animal like weasel or fox was staring at me. I got a little panicky, thinking I might be eaten, for the first time. And from the other side, my friend was crying out «Run away!»
I hurriedly tried to escape but I could hardly move forward.
It was utterly peculiar.
I had not walked yet since I became a snake.
And I don't know how to go forward.
That big animal had munched me while I was trying to move…
It was the first time I was eaten. Surprisingly, it wasn't painful at all and even bracing.

Next year, I realized this dream as a beautiful lolly with nineteen connected bicycle-like tools which can hardly be ridden. However it is supposed to be as if it can not be ridden alone but can be ridden when it is connected.

After that I had dreamed dreams so far.
Some dreams were realized on earth by my art work. The rest are lost in the jungle.
In the jungle where I lost days and nights, out of civilization, I'm just dreaming.
Dreaming is folly but dreaming is my business.

Yutaka Sone

Jonathan Borofsky

USA

born 1942

Dream Drawings

1971–87

70 photocopied drawings,

each 21 x 27 cm

Courtesy the artist

I dreamed that Salvador
Dalí wrote me a letter:
2487690

[illustrated]

1979

Charcoal on wall

Dimensions variable

Courtesy the artist and

Paula Cooper Gallery,

New York

Jonathan Borofsky records his dreams, not to unlock the secrets of his own unconscious, but as a quest for images that have relevance and resonance for many people. He began to use his dreams in his work from around 1973, recycling and transforming them so that a single dream may emerge in several different incarnations – as a drawing on paper or on the wall, a painting on canvas, a sculpture or an installation. Drawing is at the heart of his artistic practice, its quality of immediate transcription central to the communicative and collaborative impulses which shape his art. Recording all his dreams, he selects only those which seem accessible and relevant to other people. Of a painting called *The Flying Man with Briefcase at 2,816,963* Borofsky has written: 'No matter how personal I get about myself, my work is going to have meaning for somebody else. So, this figure is me too – the travelling salesman who goes around the world with his briefcase full of images and thoughts. The briefcase has always been a metaphor for my brain.'[1]

The rhythm and repetition associated with keeping a dream diary is echoed in Borofsky's practice of numbering his works.

1
Quoted in Mark Rosenthal
and Richard Marshall,
Jonathan Borofsky,
New York, 1984

Louise Bourgeois
USA
born 1911, Paris

Untitled
1996
Red ink on paper
22.9 x 30.5 cm
Courtesy Cheim & Reid,
New York

Untitled
1996
White gouache on blue paper
25.4 x 15.2 cm
Courtesy Cheim & Reid,
New York

Untitled
1997
Pencil and ink on paper
22.9 x 29.2 cm
Courtesy Cheim & Reid,
New York

Untitled
1997
Pencil and red ink on paper
22.9 x 29.2 cm
Courtesy Cheim & Reid,
New York

Mosquitoes
1997
Red ink on paper
30.5 x 22.9 cm
Courtesy Cheim & Reid,
New York

Louise Bourgeois draws in the evenings and at night when she can't sleep, retracing and reviewing her thoughts, memories, obsessions, angers, fears and joys. In many ways these nocturnal drawings can be understood as a kind of Freudian dreamwork – the representation of a dream in another form (usually words), from which an understanding of the dream's personal significance to the dreamer may be reached. Bourgeois' drawings are dream-like, ambiguous, open-ended entities with many shifting interpretative possibilities. The artist's drawing activity is compelling and insistent, producing hybrid images which, like dream imagery, seem always in flux, simultaneously proposing and denying the possibility of revelation. In fact the artist is interested in and has written on the work of Sigmund Freud: 'I simply want to know what Freud and his treatment can do, have tried to do, are expected to do, might do, might fail to do, or were unable to do for the artist here and now. The truth is that Freud did nothing for artists, or for the artist's problem, the artist's torment – to be an artist involves some suffering. That's why artists repeat themselves – because they have no access to a cure.'[1]

Untitled
1998
Red ink on paper
19.1 x 25.4 cm
Courtesy Cheim & Reid,
New York

**Untitled (I can or will fall
asleep...)**
[illustrated]
1998
Pencil and red ink on paper
22.9 x 30.5 cm
Courtesy Cheim & Reid,
New York

© Estate of Louise
Bourgeois – VAGA, NY and
DACS, London 2000

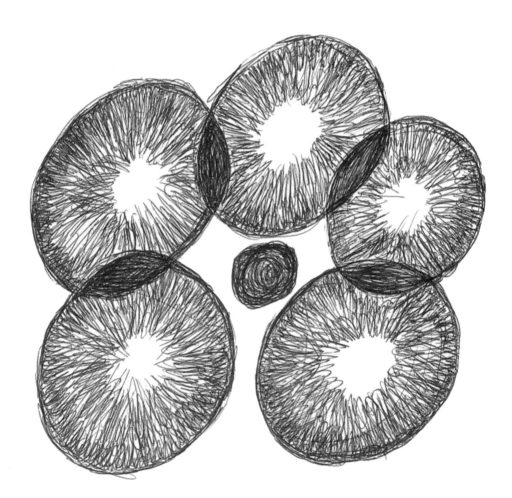

Adam Chodzko
England
born 1965

Night Vision
1998
Two-screen synchronized
video projection with sound
Running time: 16 minutes
20 seconds
Courtesy the artist
Photograph: Justin Webster

The gap between imagination and representation, between dream and art, is the subject of *Night Vision*. In making this work, Adam Chodzko invited lighting designers and technicians of rock concerts, theatre productions and raves, to describe how they would 'light heaven'. The artist lets the unconscious poetry of the technicians' specifications speak directly to the imagination of the audience. We hear their descriptions while watching an infra-red film of lights and equipment being installed at night in a rainy wood:
'I'd put a 20 or 10K behind a huge frame with graduated gels; just strips of gels across, creating all your graduated colours and they'll bleed into each other and they'll create a rainbowy effect. To stave off the darkness you'd have to blast it with a lot of light. You'd have to put a lot of light source in there…'

Listening to the technicians, the viewer may become seduced by the magic of the heaven they describe, seeing it clearly in the mind's eye. When one of the technicians on screen suddenly peers into the night and throws a switch, causing the results of their work to flash up on the opposite wall, the long-awaited view of 'heaven' is an inevitable anticlimax.

Lygia Clark
Brazil
1920–88

**Baba antropofágica
(Cannibalistic Slobber)**
1973
Single-screen video
Extract from the film
O mundo de Lygia Clark
Directed by Eduardo Clark
Re-edited by Susan Hiller
Lent by Guy Brett

'It all started with a dream that kept coming back to me. I dreamt that I opened my mouth and took out a substance incessantly. As this was happening, I felt as if I was losing my own internal substance, which made me very anguished mainly because I could not stop losing it. In the work I made afterwards, which I called *Baba antropofágica*, people had cotton reels in their mouths to expel or interject the substance.'[1]

Clark developed this work with her students in Paris, and wrote of it: 'A person lies down on the floor. Around him young people who are kneeling down put different coloured reels of thread in their mouths. They start pulling out with the hand the thread which falls over the person lying down until they unravel the whole reel. The thread comes out full of saliva, and the people who are pulling out the thread begin by believing they are pulling out a thread, but then they realize that they are pulling out their very insides… We arrived at what I call *corpo coletivo* (collective body) which, in the last analysis, is the exchange between people of their intimate psychology. This exchange is not a pleasant thing… It is an exchange of psychic qualities and the word "communication" is too weak to express what happens in the group.'[2]

1
Quoted in Guy Brett,
'Lygia Clark: The Borderline
between Life and Art',
Third Text, no. 1, 1987

2
From a letter to Hélio
Oiticica, 6 July 1974

David Connearn
England
born 1952

1.4 mm line of black ink, drawn 56½" long and repeated to its square
Ink on 300 gsm Heritage Reg. paper over polythene
203.2 x 203.2 cm
Courtesy the artist

1.4 mm line of black ink, drawn 56½" long and repeated to its square
Ink on 300 gsm Heritage Reg. paper over polythene
203.2 x 203.2 cm
Courtesy the artist

This illustration was drawn specially for the publication

David Connearn's work is the result of a disciplined meditation, governed by a pre-determined set of rules. The artist's activity is calmly monotonous and repetitive, its results inducing a trance-like state in the viewer. Lines drawn one below the other, each repeating exactly the one before, magnify each other's slips and tricks, operating a game of visual Chinese whispers whereby the last line reveals any hesitation or over-confidence buried within the first. In retracing Connearn's faithful rendering of the details of the minute slippages which flow down the work like ripples, destabilizing its surface, the viewer experiences a change of pace and perception. Cumulatively, attention to these shifting lines and vacillations captures both artist and viewer in a fluctuating circularity of production and reception.

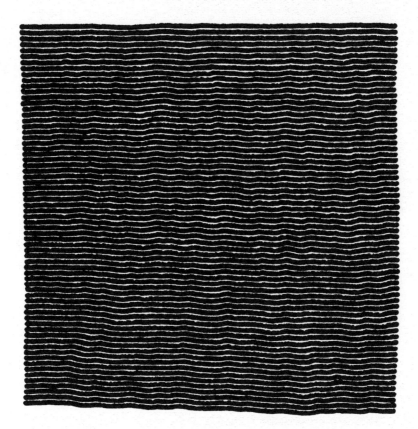

Minerva Cuevas
Mexico
born 1975

Drunker
1995
Single-screen video with
written texts
Running time: 70 minutes
Dimensions variable
Courtesy Galería
Kurimanzutto, Mexico City
© the artist 1999

This work documents
the artist's progressive
descent into a state of
complete intoxication.
In real time, a stationary
video camera records
her drinking her way down
a bottle of tequila while
writing with the fixed
concentration of a
punished schoolchild
writing lines. The
increasing disorder of the
writing is exhibited as part
of the work – 'I drink not
to feel… I'm not drunk…
I drink to talk… I'm not
drunk… I drink to forget…
I drink to remember…
I'm not drunk…'
The sense of personal
testimony and assertion
of identity in the face of
the artist's disintegrating
control over her actions
emphasizes the role of
the video camera as
a witness. The work
registers the passing
of control from artist to
camera as, for the last
20 minutes of the work,
it records activities of
which the artist has
absolutely no memory.

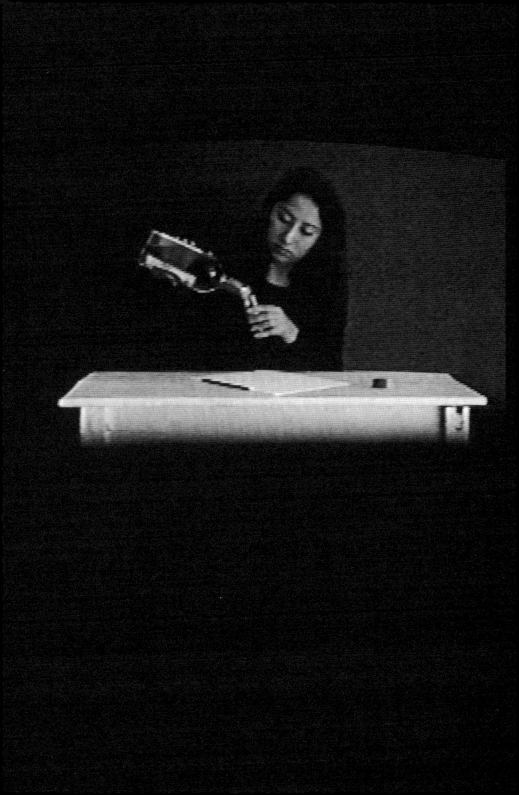

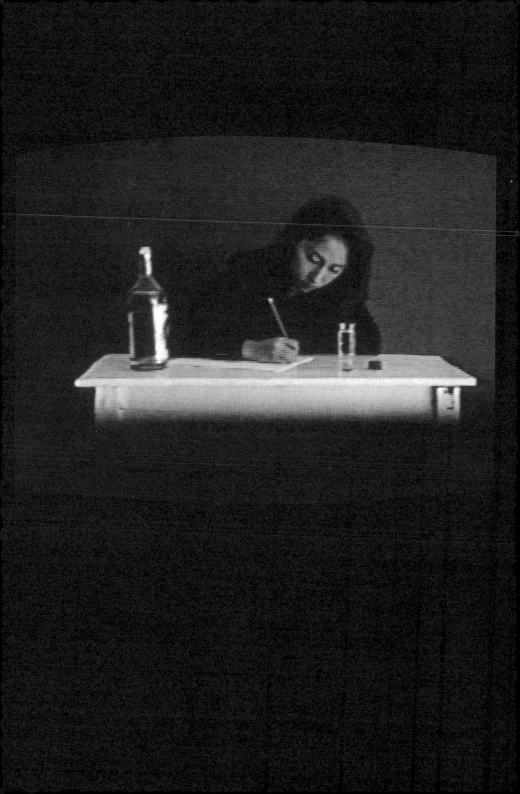

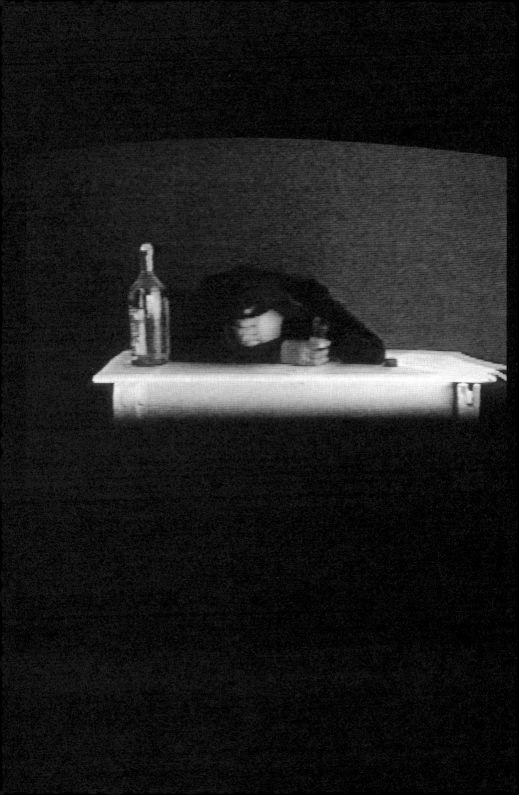

Leif Elggren
Sweden
born 1950

Talking to a Dead Queen
1994
CD, recorded live
Sound source: Cu-pipe,
376 x 1.2 cm, connected
to an amplifier
FYCD 1008 (p) & (c), 1996
Fylkingen Records

**The Kingdoms of
Elgaland-Vargaland**
[illustrated]
1992
Carl Michael von Hausswolff
and Leif Elggren
Courtesy Andréhn-
Schiptjenko, Stockholm

Talking to a Dead Queen is a séance. Its uncanny effect is based on the usually unacknowledged strangeness of sound recording, by means of which the dead can play music to us and speak to us. This audiowork turns the tables as the artist tries to establish a means of communicating from the living to the dead. The work documents his attempt, and at the same time repeats it with each and every playback, drawing listeners into the work as active participants. The Queen to whom the title refers is Queen Christina of Sweden (ruled 1632–54). The work was inspired by Napoleon's prison diary, which records that he experienced several visions of tall, luminescent copper poles hanging in the void, which seemed to give out low vibrating tones while emitting the voices of dead personages offering him military advice. Here Elggren emulates Napoleon's visions by using a thin, vibrating copper pole connected to an amplifier and his own body as the conductor of the soundwaves.

As well as trying to dissolve the barriers to the communication between the living and dead, Leif Elggren, together with Carl Michael von Hausswolff, has created an imaginary kingdom called Elgaland-Vargaland which claims absolute sovereignty over lands both geographical and conceptual. It lays claim to the hypnagogic state between sleeping and waking and to the space between the borders of all existing countries and territorial waters. Nation states meet states of mind in a country to which anyone can apply for citizenship.

The Kingdoms of Elgaland-Vargaland

With effect from the 14th of March 1992,
we are annexing and occupying the following territories:

I.

All border frontier areas between all countries on earth, and all areas (up to a width of 10 nautical miles) existing outside all countries' territorial waters. We designate these territories our physical territory.

II.

Mental and perceptive territories such as: the Hypnagogue State (civil), the Escapistic Territory (civil) and the Virtual Room (digital).

On the 27th of May 1992 at 12 noon GMT, we proclaimed the state of Elgaland-Vargaland.

Digital territory address: http://www.it.kth.se/KREV/

Leif Elggren CM von Hausswolff

Barbara Ess
USA
born 1948

No Title
[illustrated]
1997
Silver gelatin print, #3/18
24.5 x 26.95 cm
Courtesy Curt Marcus
Gallery, New York

No Title
1996
Colour photograph, # 2/5
124.9 x 156.8 cm
Courtesy Curt Marcus
Gallery, New York

No Title
[illustrated]
1997–98
Colour photograph, # 2/5
38.2 x 156.2 cm
Courtesy Faggionato
Fine Arts, London

No Title
1997–98
Colour photograph, # 4/4
120.6 x 166.3 cm
Courtesy Faggionato
Fine Arts, London

The strange, hallucinatory figures in Barbara Ess' photographs hover somewhere between memory and imagination, childhood experience and dream. We may think we know the little girl with lights on her dress; that we once glimpsed the abject angel perched on top of the wardrobe; or that we can recall the summer's day when our long, long legs seemed to stretch out endlessly. The artist captures these elusive sensations and images by using a pinhole camera and a long exposure to produce a soft-focus image with an infinite depth of field. The rudimentary home-made technology, low viewpoint and sense of tunnelling space in the dramatic shadows of her photographs create an eerie, unsettling world of subjective vision. When Barbara Ess uses colour, it seems to come from an inner dream-like palette, achieved by printing black and white negatives on to coloured paper, using filters to achieve the subjective colour effects. Rather than distancing either the photographer or the viewer through the mechanism of the camera, these photographs pull both into an exchange of personal memory and association.

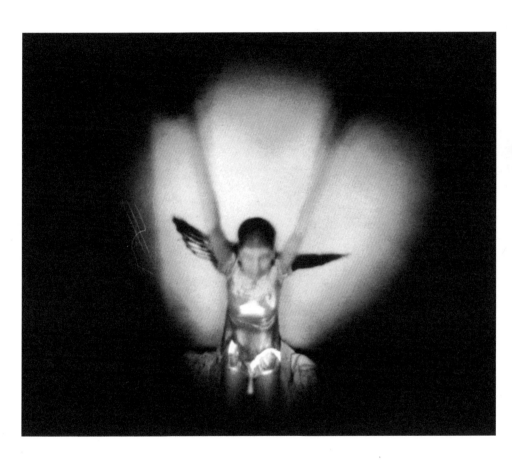

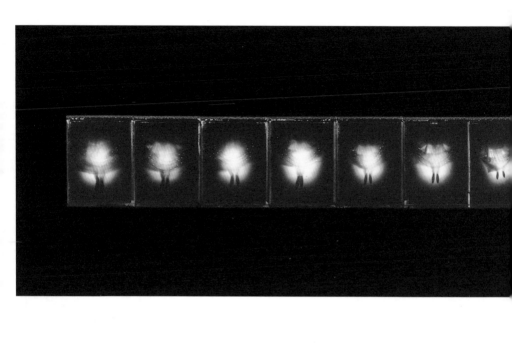

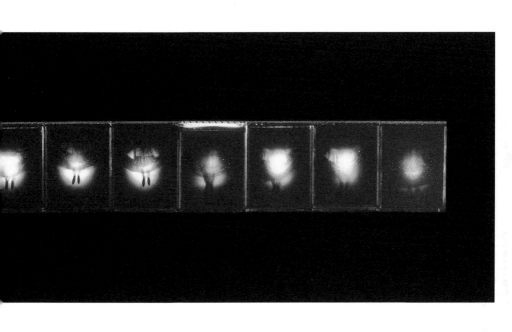

Joel Fisher
USA
born 1947

Responsibility (Horizontal)
1980
Sugar lift aquatint with
hardground etching and
chine collé
Plate size: 100.4 x 105.3 cm
Published by Crown Point
Press, 1980
Courtesy Joel Fisher
Work loaned by Jenny Todd

Responsibility (Vertical)
[illustrated]
1980
Sugar lift aquatint with
hardground etching and
chine collé
Plate size: 120 x 90.6 cm
Published by Crown Point
Press, 1980
Courtesy Joel Fisher
Work loaned by Jenny Todd

Hypnosis creates a heightened state of awareness in which the subject has uncensored access to subconscious memories. In 1980 Joel Fisher asked a hypnotist to regress him to the age of three, the age of his young son. Re-experiencing a child's perception, he made a scribbly drawing. Later, he made etchings from this drawing and a drawing by his son Noah, combining them through a process called *chine collé*, a printing technique which allows two prints to be joined together. The child's drawing forms the principal part of the work, with Fisher's separated out and on yellowed paper: 'If I really were three years old when I did my scribble, Noah's drawing would be thirty years younger than mine, so it indicates a strange time…' Asked about the experience later, the artist remarked:
'The function of drawn lines changes as we grow up. In the beginning, the drawings that develop are like creations of spaces in which an activity could happen or into which an activity could move. To a child lines are very real so that you move in the space between them. It's a very special space that exists before the possibility of drawing something arrives. You inhabit this space. It's architecture. And what's more, it's not as simple as the one, two, three dimensions we learn at school.'[1]

1
From an interview with
Robin White in *View*, Vol. III,
No. 4. July 1981

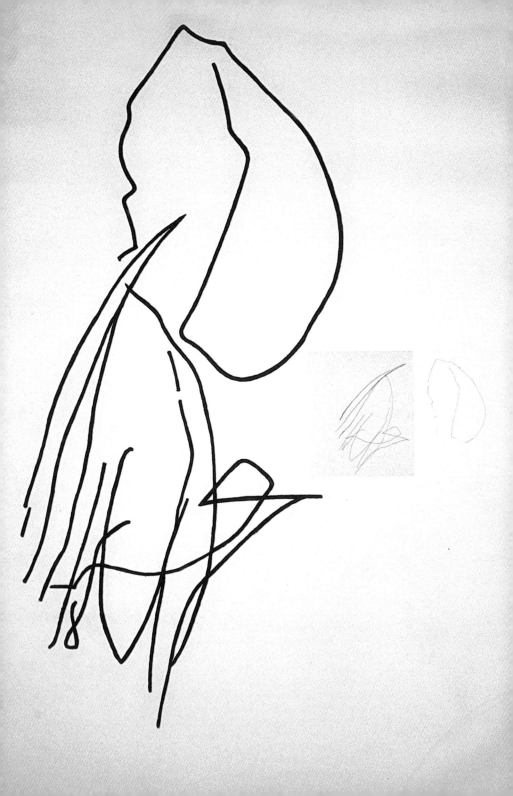

Henry Flynt
USA
born 1940

The Dream Reality
From *Blueprint for a*
Higher Civilization,
1975
Multhipla edizioni, Milan,
edited by Germano Celant
Photograph: Mike Fear

Henry Flynt's essay
The Dream Reality uses
the artist's own dreams
as material for a study of
dreams as literal reality.
Placing dreams 'on the
same level as waking
episodes' he seeks
'reality clues' in dreams
and daydreams, making
connections between the
worlds of sleeping and
waking, and working
towards a theory of
'controlled dreaming'.
Flynt's essay is couched in
the language of empirical
investigation – a quasi-
scientific dissertation on
methodology, evidence
and analysis. It is an
extract from his book,
Blueprint for a Higher
Civilization, which calls
for the abandonment of
art, science and politics
as suitable avenues for
human thought, instead
proposing dream reality
as a new intellectual basis
for the establishment of
a higher civilization.

BLUEPRINT
FOR A HIGHER
CIVILIZATION

by
henry flynt

multhipla edizioni, milano

Alberto Giacometti
France
1901–66, Italy

Le Rêve, le sphinx et la mort de T.
From *Labyrinthe*, No. 22,
1946
Edited by Albert Skira
Facsimile of authorized
reprint edition, New York:
Arno Press, 1968
© ADAGP, Paris and DACS,
London 2000

Alberto Giacometti's text *The Dream, the Sphinx and the Death of T.* recounts a profoundly disturbing dream and the artist's attempts to make sense of it in two and three dimensions, by writing it down, and by making drawings of charts and sculptural structures: '…In spite of myself I began to express the dream differently. I had tried to express in a more precise and striking way what had happened to me… I wanted to say all this in a uniquely affective manner, to make certain points hallucinatory but without attempting to find the connection between them… There was a contradiction between the affective way of expressing what I had found hallucinatory, and the series of facts which I wanted to describe. I found myself confused in a mass of events, places and sensations… I saw the design turn into an object: a disc with a radius of nearly two metres… With strange pleasure I imagined myself walking on this disc – time – space – and reading the story before me. The freedom to begin when I liked, for instance to start off from the dream in October 1946 and, having gone all the way round, to land a few months earlier in front of the objects in front of my towel.'

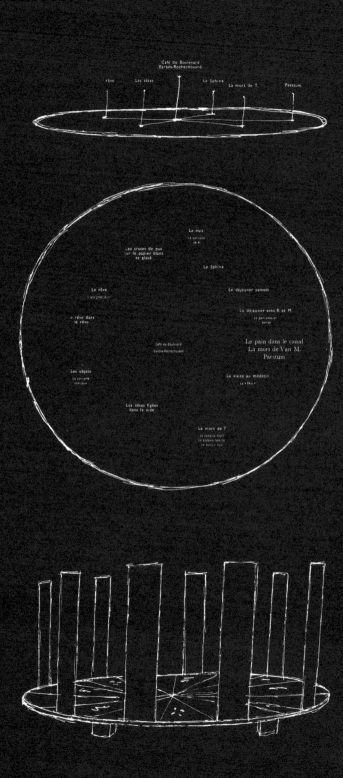

Jane Gifford
England
born 1955

Bordeaux Diary
1996
Ink and crayon on exercise
book paper
65 sheets,
each 20.8 x 32.5 cm
Installation 166.6 x 259.7 cm
Courtesy the artist
Photograph: Mike Fear

Jane Gifford has been keeping a dream diary for the past nine years. *Bordeaux Diary* was made immediately after a working trip to Bordeaux, when the artist was working on drawings and paintings for the film *La Cousine Bette*. Deciding to use the material from this trip as the basis of a work, the artist transcribed all her dreams, leaving blank those days on which she forgot them and on one occasion substituting a colleague's dream in which she had featured. To the dream accounts and images she added extracts from her waking diary which recorded a very particular mental state – that of being away from home, producing visual work to very short deadlines but unable to concentrate on her own art. To accentuate her feelings of alienation and isolation she drew *Bordeaux Diary* on pages taken from a French exercise book, apart from the material from the two days before she went, a short trip home in the middle and the days immediately following her return, for which she used familiar English notebook paper. Although the artist is not primarily interested in revealing the secrets of her unconscious, the work merges waking and dreaming realities in an unsettling, highly personal way with which viewers may identify.

THURSDAY 27 JUNE 96 BORDEAUX

JAMIE'S NOT HERE. THE BLUE FLOWERS HE GAVE ME
HAVE DRIED UP. IGLAZED THE CUPIDS. CHANGED
THE PORTRAIT A LOT. THE COLOURS OF THE DRESS
DECORATION, ARCHITECTURE, SORTED OUT FACE +
HAIR READY FOR GLAZING TOMORROW. WENT TO PARC
DES EXPOSITIONS - I KM LONG GIOVANNI HAD SET
UP EVERYTHING + DONE A SMALL COLOUR TEST +
STARTED TO STRETCH CANVAS OVER HESSIAN

I was in the Street with my bicycle which
had a vase of fresh flowers attached at the
front and something hanging down which
was in danger of stopping the spokes of the
back wheel. Someone was shouting at
Someone else for having a killer something
on his bike — a long metal spike which could
suddenly stop the wheel

FRIDAY 5 JULY 96 BORDEAUX

FIDDLED ABOUT WITH LARGE FLAT THEN I
STARTED MY LEG AFTER LUNCH. FILLED IT IN
QUICKLY THEN IT WENT VERY PURPLE. I GOT VERY
TIRED MID AFTERNOON WITH TIRED FEET, THEN
FOUND A SURGE OF ENERGY + WORKED ALLOVER
IT - I MADE THE EYES MORE POINTED, MORE LIKE
GIOVANNI'S AND EVERYTHING LESS PURPLE

I had found two small snakes. I
wasn't scared of them. I was going to
keep them, maybe in a paper bag. I
thought they might mate, though I
didn't know what sex they were

Gilbert & George
England
born 1943, Germany
& 1942, England, working
together since 1968

Gordons Makes Us Drunk
1972
Single-screen video
Running time: 12 minutes
Tate Gallery, purchased 1972
Photograph: Mike Fear
© the artists 2000

In an interview in 1974, Gilbert & George stated that their drinking was purely artistic, that they drank to see the world in a new way, to enjoy a kind of out-of-body experience: 'The embarrassment of the insistence one gets with drinking. One sometimes gets an idea when drinking and really insists on that. Some funny idea, you know. Someone has to do something, or make the table turn round, and in some drunken way it seems exactly what you want…'

This insistence is the theme of *Gordons Makes Us Drunk*, a video sculpture located in the artists' own home, where the refrain 'Gordons makes us drunk' is repeated over and over again like an incantation as the artists apparently enjoy a bottle of gin, retaining their studied decorum throughout. This 'sculpture on video tape' is in keeping with the artists' permanent incarnation as 'living sculptures'. Two years earlier Gilbert & George had offered 'Six points towards a better understanding' of their work:

'Essentially a sculpture, we carve our desires in the air. Together with you this sculpture presents as much contact for experiencing as possible. Human sculpture makes available every feeling that you can think of. It is significant that this sculpture is able to sing its message with words and music. The sculptors, in their sculpture, are given over to feeling the life of the world of art. It is intended that this sculpture brings to us all a more light generous and general art feeling.'

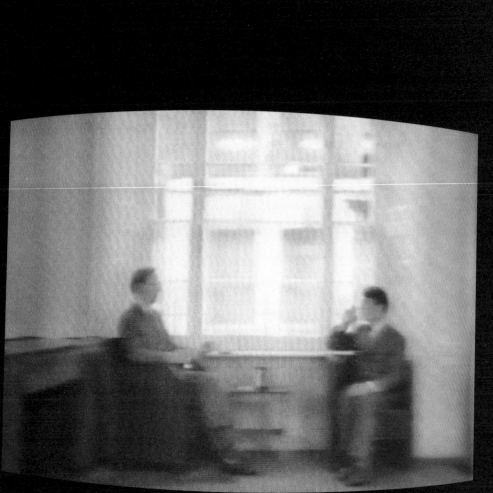

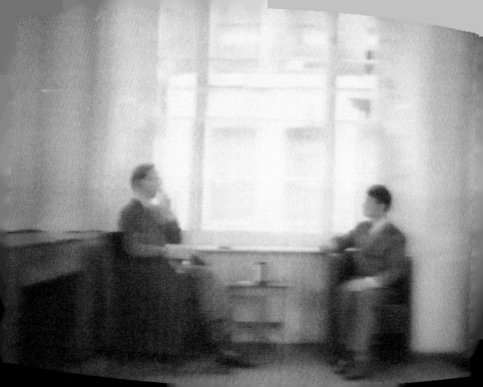

Alison Gill
born 1966, UK

Time Capsule #1
[detail illustrated]
1999
Metalicized polyurethane
resin
15 x 170 x 170 cm
Courtesy the artist and
Sabine Wachters Fine Arts,
Belgium
Photograph: Elisabeth
Scheder-Bieschin

Alison Gill's *Time Capsule* is a group of chrome mushrooms, arranged in a fairy ring. Life-size, the mushrooms have been cast from real mushrooms, their shiny chrome surface lending them an air of other-worldliness at odds with their direct connection to objects in the real world, but in keeping with the supposedly magical properties of mushrooms. Fairy rings, springing up overnight as if from nowhere, are associated with a wealth of folklore. The mushrooms encircle a charmed space, one from which children may be spirited away, and adults lose themselves in dreaming. In the gallery, the tiny scale of the sculpted mushrooms, and their defiant defence of their magical inner circle creates an uncanny, imaginary space, perhaps the wondrous yet overwhelming space of childhood fantasy. The artist's interest in altered states of mind and the power of imagination is evident in this work, in which she skilfully transforms material into models of things which are themselves vehicles of transformation and objects of veneration.

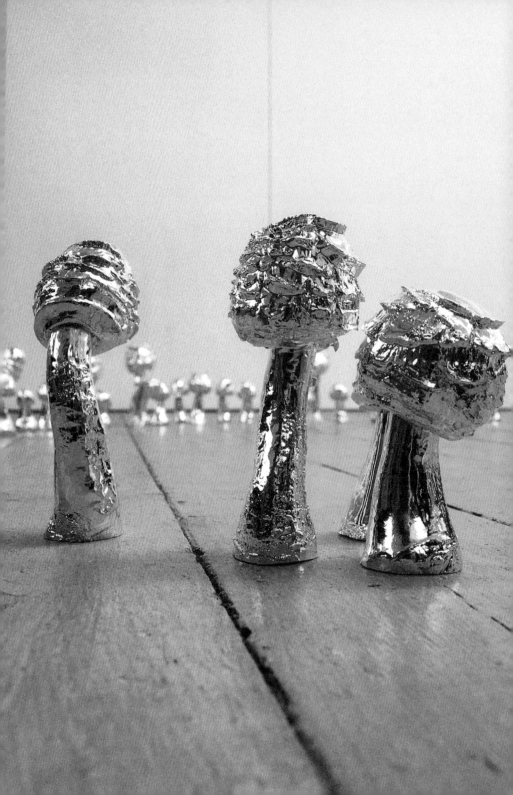

Douglas Gordon
Scotland
born 1966

30 Seconds Text
1996
Text on black wall, lightbulb,
timing device
Typefaces: Helvetica
and Bembo
75 cm column width
Edition 2
Sammlung Goetz, Munich
Photograph: Paul Litherland,
OPTICA
© the artist and the Lisson
Gallery 2000

Entering a dark room the viewer is disorientated, uncertain. A light flashes on, illuminating a text printed directly on to the wall. The text relates a macabre tale of a doctor trying to communicate with a condemned man's head directly after it had been severed by the guillotine, and apparently succeeding for between twenty-five and thirty seconds. At the end of the text, the artist writes that it should have taken the viewer the same amount of time to read this far. The light goes out, plunging the viewer once more into darkness and the sudden realization that they are in the shoes of the dead man, all interaction cut short. The effect is akin to an out-of-body experience – it transports you into another world, another body. Douglas Gordon has talked of his interest in the selective possession or abduction of material from one context to another. Here, although the text has been taken from the Archives of Criminal Anthropology in Paris, it is the viewer who has been mentally kidnapped.

30 seconds text.

In 1905 an experiment was performed in France where a doctor tried to communicate with a condemned man's severed head immediately after the guillotine execution.

"Immediately after the decapitation, the condemned man's eyelids and lips contracted for 5 or 6 seconds...I waited a few seconds and the contractions ceased, the face relaxed, the eyelids closed half-way over the eyeballs so that only the whites of the eyes were visible, exactly like dying or newly deceased people.

At that moment I shouted "Languille" in a loud voice, and I saw that his eye opened slowly and without twitching, the movements were distinct and clear, the look was not dull and empty, the eyes which were fully alive were indisputably looking at me. After a few seconds, the eyelids closed again, slowly and steadily.

I addressed him again. Once more, the eyelids were raised slowly, without contractions, and two undoubtedly alive eyes looked at me attentively with an expression even more piercing than the first time. Then the eyes shut once again. I made a third attempt. No reaction. The whole episode lasted between twenty-five and thirty seconds."

...on average, it should take between twenty-five and thirty seconds to read the above text.

Notes on the experiment between Dr. Baurieux and the criminal Languille (Montpellier, 1905) taken from the Archives d'Anthropologie Criminelle.

Dan Graham
USA
born 1942

Rock my Religion
1982–84
Running time: 55 minutes
Courtesy Electronic Arts
Intermix, New York
Photograph: Mike Fear
© the artist and the Lisson
Gallery 2000

Rock my Religion uses a combination of documentary film, footage of rock concerts, voice-over and screened text to juxtapose a history of non-conformist religion in America with the rise of rock music. Opening with the Shakers, the film discusses the circle dance, trance, possession by demons and speaking in tongues, overlaid and intercut with images of the frenzied gyrations of rock bands and their audiences. The artist carefully manages the congruities and incongruities inherent in this juxtaposition – 'Shake off your flesh' is the persistent refrain of the opening sequences. The film continues to the strains of *God'll Walk Behind You* and Jerry Lee Lewis' *Great Balls of Fire*, to examine Puritanism and Native American religions based on the ghost dance, the rise of the American teenager ('their philosophy is fun. Their religion is rock and roll') and the free love and drug culture of the hippies.
'Rock performances electrically unleash anarchic energies to provide a hypnotic, ritualistic trance for the mass audience, especially when both musicians and audience are under the influence of psychedelic drugs. Such shows suggest the transport of the tent meeting or the Shakers' deliberate seeking out of the devil in order to purify themselves and ensure a communion with God.'

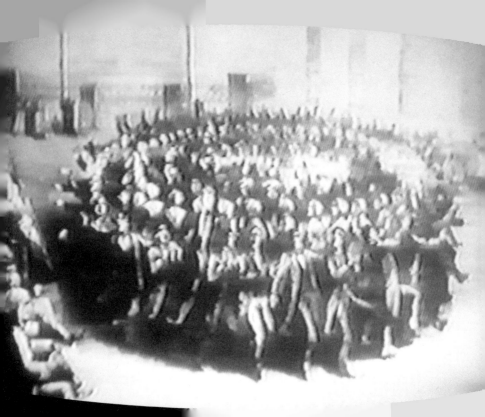

Rodney Graham
Canada
born 1949

Halcion Sleep

1994
Video projection
Running time: 27 minutes
Private collection, London
Photograph: Stephen White,
London

This projection work shows the artist asleep in the back of a car, being driven through a rainy night to his apartment in Vancouver. He has taken a sleeping pill called Halcion in a motel room on the outskirts of the city before being picked up for the drive home. Relinquishing all control, the artist has made a return to the passivity and imaginative insularity of a child, dreaming his own dreams while being transported according to the whims of his parents. The work documents a particular deliberately-staged experience undergone by its maker, but it also acts directly on the viewer. The steady motion of the car negotiating the city and the blurred lights moving past the windows hypnotize the viewer into a trance-like state in which to empathize with the artist's condition. The viewer enters the artist's dreams, empty spaces in which to redefine experience.

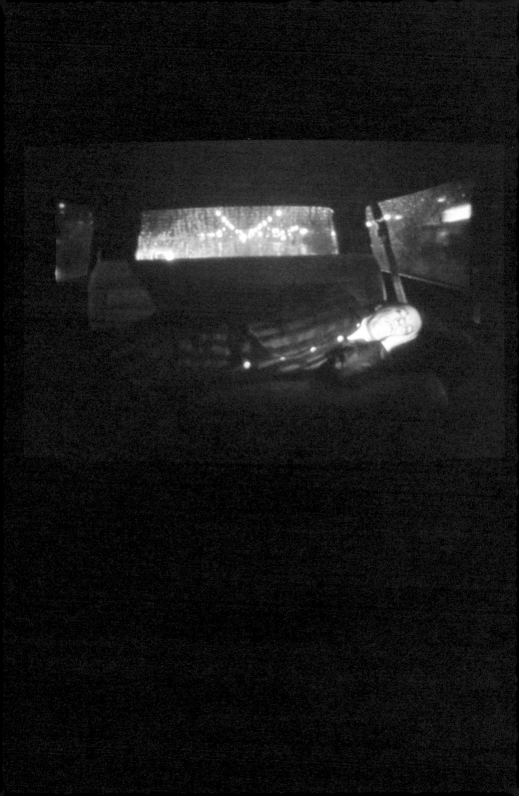

Brion Gysin &
Ian Sommerville
England
1916–86 & 1940–76

Dreamachine
1960
Remade by Adrian Fogarty,
2000

The purpose of the *Dreamachine* is to stimulate imagination, image formation and visionary experience. It consists of a revolving cardboard cylinder with a light bulb at its centre, turning at 78 rpm. Light emerges through configurations of slots and holes cut in the cardboard. 'You look at it with your eyes shut and the flicker plays over your eyelids. Visions start with a kaleidoscope of colours on a plane in front of the eyes and gradually become more complex and beautiful, breaking like surf on a shore until whole patterns of colour are pounding to get in…'[1] The painter Brion Gysin and the mathematician Ian Sommerville collaborated on the first *Dreamachine* prototypes in 1960, with the intention of disseminating the design widely to 'bring about a change of consciousness in as much as it throws back the limits of the visible world and may, indeed, prove that there are no limits.' The instructions for making the machine were published in the magazine *Olympia*, no. 2, 1962; instructions for making newer versions are currently available on the internet at: www.zenweb.com/century /red_night/dreamwhite. html

Ian Sommerville, 'Flicker', *Olympia*, Paris, 1962

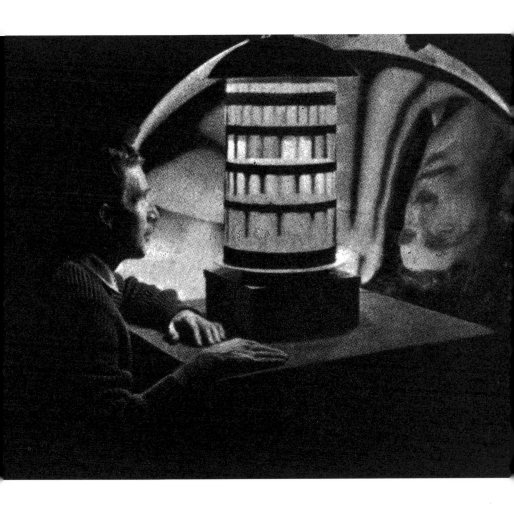

2

Mark Harris
England
born 1954, Singapore

Marijuana in the UK
1999
Two-screen synchronized
video
Running time: 9 minutes
Courtesy the artist

2

Charles Baudelaire,
Artificial Paradises, 1858

1

Walter Benjamin,
Hashish in Marseilles, 1922

This work, filling two video monitors, shows a serious young man and his mirror image reading aloud to plants. The plants are marijuana plants, the readings are from Walter Benjamin and Charles Bauldelaire. The artist's reason for reading to the plants is that the texts' references to the narcotic properties of hashish will stimulate them and improve their concentration of THC, the active ingredient of cannabis. The piece subverts the genre of artists using themselves as guinea-pigs in experiments with altered states of consciousness. Here the drug-producing plants rather than the artist are the subjects of the experiment – we are asked to study them rather than him for signs of change.

'Now the hashish eater's demands on time and space come into force. As is known, these are absolutely regal. Versailles, for one who has taken hashish, is not too large, or eternity too long. Against the background of these immense dimensions of inner experience, of absolute duration and immeasurable space, a wonderful, beatific humour dwells all the more fondly on the contingencies of the world of space and time.'[1]

'Luckily this apparently interminable fancy has lasted only for a single minute – for a lucid interval, gained with a great effort, has enabled you to glance at the clock. But a new stream of ideas carries you away: it will hurtle you along in its living vortex for a further minute; and this minute, too, will be an eternity, for the normal relation between time and the individual has been completely upset by the multitude and intensity of sensations and ideas.'[2]

Susan Hiller
England
born 1942, USA

Magic Lantern
1987
Slide projection with
soundtrack
Dimensions variable
Running time: 12 minutes
Commissioned by the
Whitechapel Art Gallery,
London
Photograph: Roger Sinek

Magic Lantern mixes circles of pure light – enlarging and reducing, overlapping and finally mixing to white – with a soundtrack of 'voices of the dead' recorded by the Latvian scientist Konstantin Raudive in empty, silent rooms interspersed with the artist's own vocal improvisations. The projected colours produce after-images on the viewer's retina so that visions of brilliant hues which are not 'really' there combine with the aurally-conjured ghosts on the tape. A machine for conjecture, the work blurs objective perception and subjective response, the simple colours and nonsense words building complex castles in the air and mind. The artist stresses that the key component of the machine is the participation of the viewer: 'I'm showing you – and showing myself, because it's a machine I can use too – that the perceptions of the body and the effect of light on the eye, the intersection of the body and desire, creates beauty, creates meaning. The piece can't be documented because the colours you're seeing are real but invisible externally. So it's specific to you but it's also collective because it happens to all of us in the audience at the same time.'[1]

1
From an interview with
Stuart Morgan, *frieze* 23,
Summer 1995

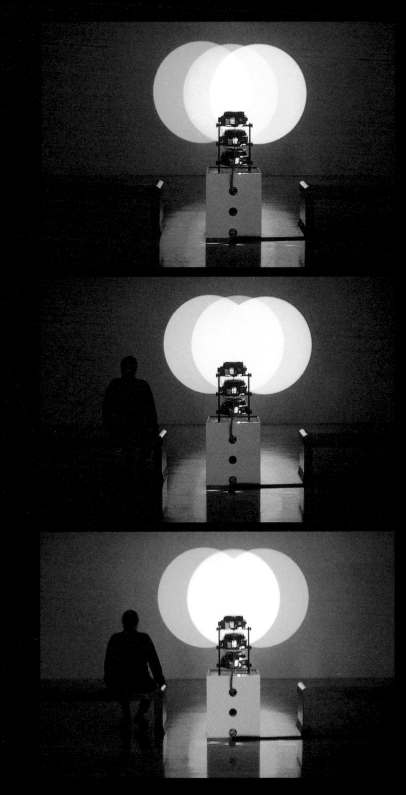

Carsten Höller
Germany
born 1961, Belgium

Charité
1997
Single-screen video
Running time: 240 minutes
Courtesy Schipper und
Krome, Berlin

Muscimol
[illustrated]
1997
Single-screen video
Running time: 12 minutes
Courtesy Schipper und
Krome, Berlin

Muscimol Third Try
1997
Single-screen video
Running time: 14.8 minutes
Courtesy Schipper und
Krome, Berlin

Pilzkoffer
(Mushroom Case)
1997
Suitcase and mixed media
40 x 38 x 32 cm
Private collection, Cologne
Courtesy Schipper und
Krome, Berlin

In these works Carsten Höller seems to document his experimentation with fly agaric mushrooms, merging subjective experiences with the apparently objective recording of the ever-present video camera. In *Muscimol*, we see him entering a hotel room with a suitcase, as if arriving for the first time. As he goes to draw the curtains, however, we notice that he is in pyjamas. He proceeds meticulously to unpack a basket of fresh mushrooms, carefully fry them in the hotel bathroom and then slowly eat them. We then watch him doze, watch TV, sleep and dream of a mushroom revolving in a wood, its colour changing from red to blue. He mutters in his sleep: 'I'm aware I'm aware of it. At the same time I'm aware I'm not aware of it.' Finally, we realize that there is another person in the room, waiting for the artist's 'transformation into a saviour'. The artist's visions complete, he shaves and allows the onlooker to cut his hair before leaving the hotel room again with his suitcase, this time fully dressed, a sober, suited man, who although internally transformed, remains externally unremarkable.

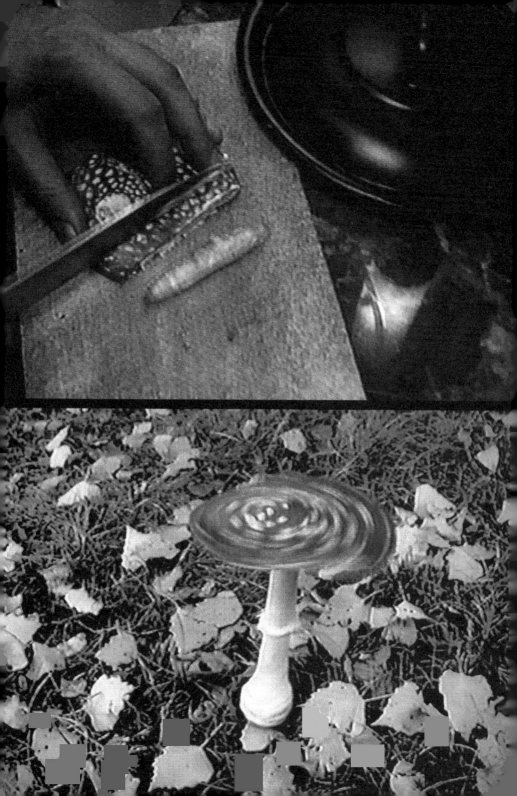

Shirazeh Houshiary
England
born 1955, Iran

Last Gasp
[illustrated]
1998
Aquacryl on canvas with graphite
190 x 190 cm
Courtesy Lisson Gallery, London
Photograph: Elisabeth Scheder-Bieschin
© the artist and the Lisson Gallery 2000

Air
1999
Aquacryl on canvas with graphite
190 x 190 cm
Courtesy Lisson Gallery, London

Shirazeh Houshiary's work is rhythmic, repetitive, almost trance-like in nature. Working on the floor, she writes a word in pencil over and over again on to a black canvas. The word shrinks and stretches as she works, spiralling into and out of the black ground, losing meaning in its seemingly endless repetition. Intending the work to transcend boundaries of culture and individual identity, the artist does not reveal the meaning or the origin of the word she uses, repeating it almost by rote, like a mantra or a prayer learned by heart. The finished canvasses have a ghostly quality, the marks on them more like breath on a dark window than the results of laborious artistic activity. Houshiary has spoken of darkness as a 'matrix' out of which forms and meanings may be summoned. With this work, however, she talks of a seeking after formlessness, a writing out of meaning, an erasure.

Job Koelewijn
USA
born 1962, The Netherlands

Body Warmers
1999
Vests with CD Walkman
and speakers
Dimensions variable
Courtesy Galerie Fons
Welters

You are invited to wear one of Job Koelewijn's body warmers in order to experience this work which uses the disembodied voices of poets, living and dead, as a source of psychic energy for artist and viewer. The artist explains: 'I have always thought of poetry as my primary source, because it is so disinterested – the power of the word often gives me immediate energy. I had fixed a number of speakers in the body warmer, connected to a Walkman. It is a bit like my idea of wrapping stock cubes in texts by Dante: whereas the stock cubes are a healthy concentrate of vitamins, poetry is a sort of concentrate of literature which can heal the spirit… I have recorded some of my favourite poems on a CD, among them *Spring Suite for Lilith* by the Dutch poet Lucebert, a poem that I recite loudly when I feel despairing:

Like babies poets are
 not healed
of a lonesome searching
 in their minds
many have snuffed
 out love
so as to read its light
 in darkness

In the dark everyone
 is just as bad
the purse of tenderness
 is empty soon
a few poets is all it
 brings forth
lilies are dredged up
 out of pools

Barbers butchers
 better talkers
everything that is

buried deep
godforsaken dead
 nettles let us
in your black blotches feel
 it is not too late

He who wants to
 shine must burn
go on burning if he
 captures love
to raise its darkness
 into light
for the entire community.

The poem can be read as a sort of battle-cry to give the poet fresh energy. Isn't it great, a poem like this, written to give someone new courage?'[1]

1

Extract from an interview
with Sjoukje van der Meulen
in *Job Koelewijn*,
New Sculpture Museum
Foundation, 1999

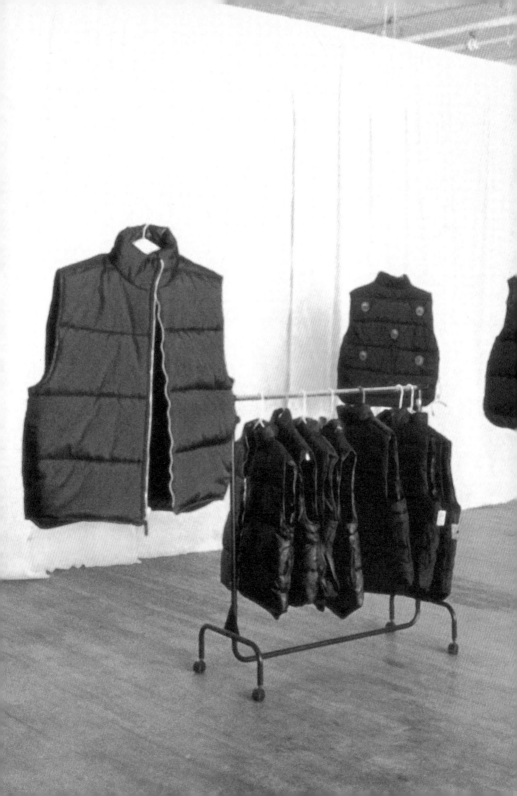

Jim Lambie
Scotland
born 1964

ZOBOP
2000
Site-specific installation with
coloured vinyl
Dimensions variable
Showroom Gallery,
London, 1999 [illustrated]
Courtesy of the Modern
Institute © the artist 1999

The whirling, fantastic shapes of Jim Lambie's floors transport the viewer into another world, familiar from the realms of psychedelia. *ZOBOP* is an installation of bright intensely-coloured strips of glossy vinyl tape. Infinitely variable in response to the location in which it finds itself, the work takes its form from the room it occupies, tracing in ever-decreasing circles the outline of the walls, hesitating whenever it encounters an obstacle and building this hesitation into a complex pattern. The magic of the work lies in its simplicity and ease of reproduction as much as in its ability to catch and hold the viewer's attention. Lambie's faithful rendering of the minute details of the edges of the gallery space, its doors and other architectural incidents, creates a fluctuating perceptual vortex which, nonetheless, remains as stable as the ground beneath our feet.

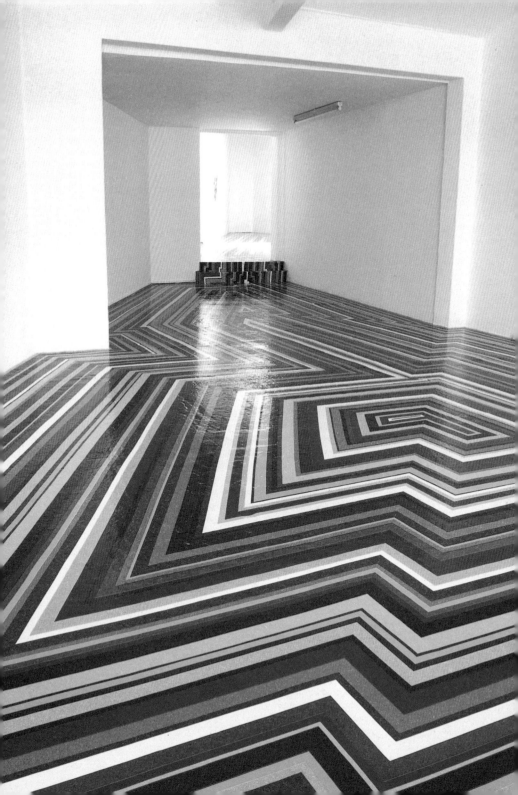

Glenn Ligon
USA
born 1960

**Dreambook Series,
No. 384, (Speechless)**
1990
Oil on paper
83.8 x 63.5 cm
Collection Emily Fisher
Landau, New York

**Dreambook Series,
No. 333, (History)**
1990
Oil on paper
83.8 x 63.5 cm
Collection Emily Fisher
Landau, New York

Glenn Ligon's *Dreambook* series of paintings is based on a type of book, once common throughout African-American communities and still available, which offers concise interpretations of dreams. Each dream is given a three-figure number and the books are intended as guides to betting in the 'numbers game', an illegal but widespread lottery. Looking up a recent dream, players find a number on which to gamble their money. Like the predictions of astrologists, the 'meanings' of the dreams are phrased in poetic, often contradictory language, open to subjective interpretation according to the present circumstances of the reader. Directly descended from ancient traditions of interpreting dreams through the symbolism of their imagery, dreams are presented as signposts to reality, easily readable clues to a grand design for the life of each individual. The dream books' heady combination of dreams, chance, fate and finance intrigues Ligon – 'some people bet their dreams and win.'

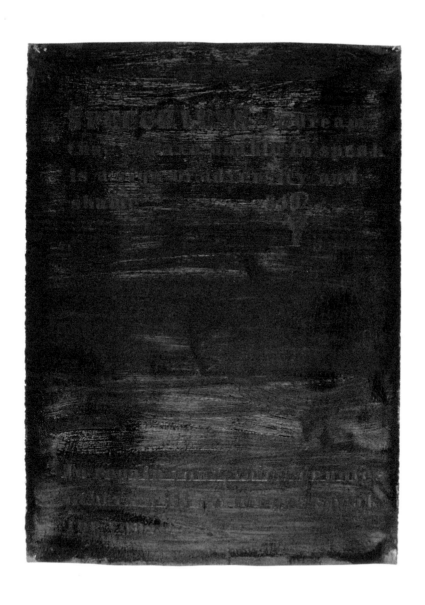

Liliane Lijn
England
born 1939, USA

Crossing Map
1983
Paperback edition,
23 x 17 cm
Deluxe edition,
24 x 14 x 18 cm
Published by Thames and
Hudson Ltd, London
Courtesy the artist
Photograph: Mike Fear

In this visionary book, word and image merge to create a shifting, transitory whole which can be read as a work of fiction, art or philosophy, consulted as a divinatory text, enjoyed as poetry or performed as an epic song-cycle. Its story concerns a woman on a voyage of exploration. Questioning the meaning of time, she plunges into her own memory and, passing into a dimension ungoverned by the rules of the here and now, encounters the 'Last Man'. Through telepathic communication with him, she is witness to the death of her society and the dematerialization of man:

'Man
The energy addict
Wanted to eat
The Universe
Knowing there was More
And hoping
To outdo Time.'
 Crossing Map came about from a dream the artist had on 1 June 1967 and her growing conviction of the interchangeable relationship between light, matter and the mind of the artist. The book is based on a desire to communicate with the reader, to encourage them to enter fully into the artist's visions. Printed according to a process whereby inks move and merge according to chance, each book is different, a personalized guidebook for an interior journey.

only a fraction
 grain of dust of a mountain
And that mote of what passed
 whatever passed
 remains

And although only the minutest fraction of what passed through
 contains the whole within it
 and the web of memory
 the perfect filter
 contains it all

I could pick and pull at it as men and women do
 I could learn learn to pick out the threads
 I could hold them
But I had let go
 or wanted to
And I wondered now if there was a way of becoming it
 entering the filter becoming the film
 going in to it
 wandering through it
 travelling and having a look around
 sitting there and observing

Seeing all I had seen
Hearing all I had heard
Feeling all I had felt

Letting all that had passed through me pass through me again
 and being all of it always and at once

 the power
 the force
 the energy
 the light

André Masson
France
1896–1987

Automatic Drawing
[illustrated]
1926
Crayon on paper
41.5 x 29 cm
Private collection, Paris
© ADAGP, Paris and DACS,
London 2000

Automatic Drawing
undated
Crayon on paper
49 x 59 cm
Private collection, Paris

André Masson's automatic drawings are as close as anything surrealism ever produced to the technique of 'pure psychic automatism' borrowed from the spiritualist mediums and celebrated in the *First Surrealist Manifesto* of 1924. Masson had no particular subject matter in mind as his hand wandered freely, producing a web of markings out of which subjects emerged as elements that were subsequently highlighted. This mediumistic process was assumed to bring to the surface ideas that would otherwise have remained in the subconscious mind. Only after the drawing was well underway did Masson permit himself to step back and consider the results, and perhaps add detailing or additional marks to achieve pictorial order. The functioning of the conscious mind was never entirely eliminated in Masson's drawings, even in their early stages, but it felt that way to the artist. Whether the reason is this inevitable residue of consciousness, or the fact that a certain individual 'style' becomes a reflex, his automatic drawings are all characterized by certain common denominators making them instantly recognizable.

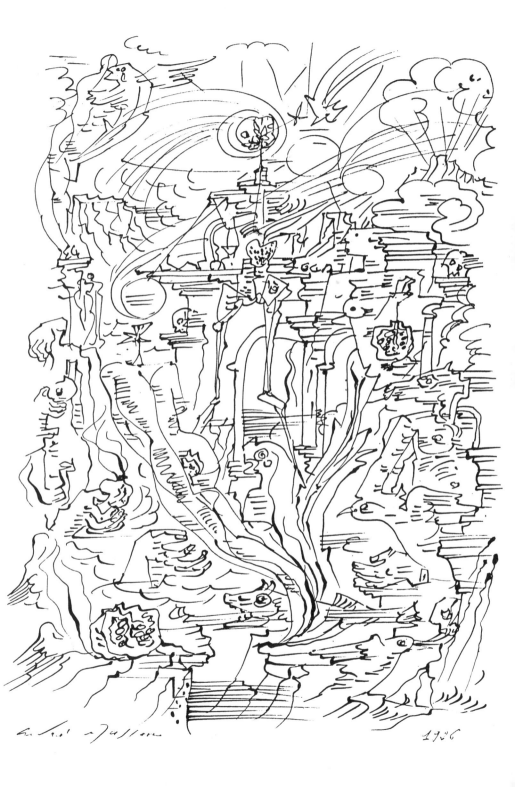

Gustav Metzger
England
born 1926, Germany

Liquid Crystal Projections
1965–98
Installation with slide
projectors, rebuilt by Adrian
Fogarty, 1998
Dimensions variable
Image courtesy Museum of
Modern Art, Oxford

Gustav Metzger's *Liquid Crystal Projections* are fully-automated phenomenological machines, intended by the artist to induce in the viewer a state of meditative trance. Thin glass slides containing liquid crystal are placed in specially adapted slide projectors fixed with heating and cooling devices and rotating polarized filters. When hot, the crystal is black. As it cools, it turns to grey, then gradually assumes the full spectrum of colour, shifting from green to yellow, purple, blue and pink, the two projectors producing an ever-changing combination of colour and light. First developed in 1965, the *Liquid Crystal Projections* were originally used by Metzger to create acid light shows for The Who, Cream and other bands, but now function on their own as machines for tranquil contemplation.

Henri Michaux
France
1899–1984

Mescaline Drawing
[illustrated]
c.1956
Crayon on paper
37 x 27 cm
Private collection
© ADAGP, Paris and DACS,
London 2000

Mescaline Drawing
c.1956
Ink on paper
32 x 24 cm
Private collection

Mescaline Drawing
c.1956–58
Ink on paper
18.5 x 13 cm
Private collection

Mescaline Drawing
c.1956–58
Ink on paper
21 x 17 cm
Private collection

Mescaline Drawing
c.1956–58
Paint on paper
27 x 22 cm
Private collection

'Strange, strange experience of mescaline, stranger than any drawing could be, even if it were to cover a whole wall with its pointed lines. When one first becomes conscious of internal images (and of external phenomena as well), it is only with a certain limited quantity of consciousness. Mescaline multiplies, sharpens, accelerates, intensifies the inner moments of becoming conscious. You watch their extraordinary flood, mesmerized, uncomprehending. With your eyes shut, you are in the presence of an immense world. Nothing has prepared you for this. You don't recognize it.'[1]

Michaux's mescaline drawings are an attempt to capture the imagery of the stranger, unrecognizable world of mescaline induced hallucination. They are a scientific as well as an artistic endeavour, the mescaline taken as an aid to production rather than for enjoyment of the state itself. The artist offers himself as a guinea-pig. In 1956 he wrote a disclaimer intended to dispel the impression that he was a drug-crazed, overtly 'visionary' artist: 'To the amateurs of one-way perspectives who might be tempted to judge all my writings as the work of a drug addict, let me say that I regret, but I am more the water-drinking type. Never alcohol. No excitants, and for years no coffee, tobacco, or tea. From time to time wine, a little. All my life, in the matter of food or drink, moderate. I can take or abstain. Particularly, abstain. As a matter of fact, fatigue is my drug.'

1
Quoted in *Henri Michaux*,
Whitechapel Art Gallery,
1999

Mescaline Drawing
c.1959
Ink on paper
32 x 24 cm
Private collection

All photographs:
Centre Cultural Tecla Sala,
Barcelona

**Images du Monde
Visionnaire**
[illustrated]
1963
Directed by Eric Duvivier
Running time: 34 minutes
Courtesy Vidéothèque
Novartis Pharma S.A.

In 1963 Michaux was closely involved with a film attempting to document mescaline-induced visions. He understood that the disappointing results of the film, called by Jean-Jacques Lebel 'a documentary on colours filmed by the colour blind', were inherent in the very nature of the project. He said:

'I have declared and repeated and I shall repeat again that it is an impossible undertaking to make a film about mescaline visions, even with a much greater budget, with all that it takes for a really exceptional production. I would say of these images before you see them, that they are insufficient. They should be more dazzling, more unstable, more subtle, more labile, more ungraspable, more oscillating, more trembling, more torturing, more swarming, more awfully coloured, more aggressive, more stupid, more strange. As to the speed, it is such that all the sequences together should be done in fifty seconds.'

Michaux's justification for undertaking the project was 'to show those who are interested in the major problem of visions how different they are to dream images, and to a certain extent to those provoked by hashish, and just where they join up to what certain mentally-ill patients have reported, for better or for worse.'

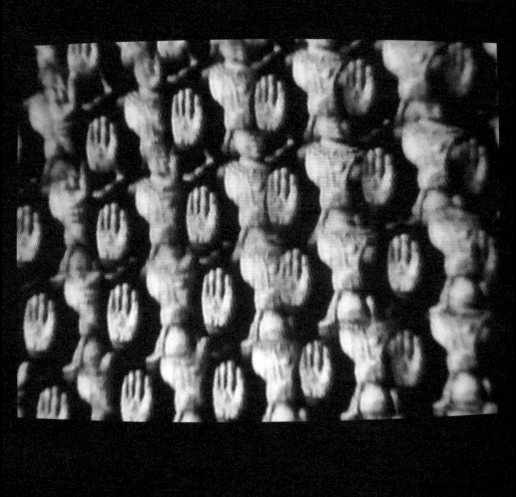

Matt Mullican
USA
born 1951

Pattern/SPA/Lecture
1998
Single-screen video
Running time: 83 minutes
Photograph: Mike Fear
Courtesy the artist

1

Matt Mullican, Introduction to
the programme notes for a
performance at the Institute
of Contemporary Art in
Boston, 1983

'The artist is not certain of the events in the performance but is confident in the unexpected. Under hypnosis, he's likely to become one of several personae – a variety of ages – as the child, as the artist in his own future, as the elderly hanging on to survival... his performance is more scientific than mystical. Although following the traditions of automatism, a theory that views the body as a machine and consciousness as a noncontrolling adjunct, some guidance into the unknown is offered by the hypnotist.'[1]

In this video documentation of three performances, made under hypnosis in 1998, we are not told the content of the hypnotic suggestion given to the artist. In *Pattern,* Mullican brings materials into an art gallery space and makes a geometric pattern in tape on the floor, then retraces it with his body, walking its shape and pacing out its rhythm. In *SPA* he occupies the pattern he has made, drinking from a bottle and interacting anew with his original intervention in the space. *Lecture* sees him making a drawing on the wall while telling stories about the nature of memory to the unseen off-screen person working the video recorder. His drawing develops according to his ideas on memory, apparently functioning together with the pattern on the floor as a kind of private memory map.

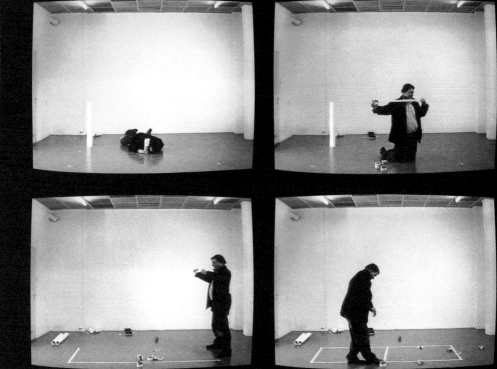

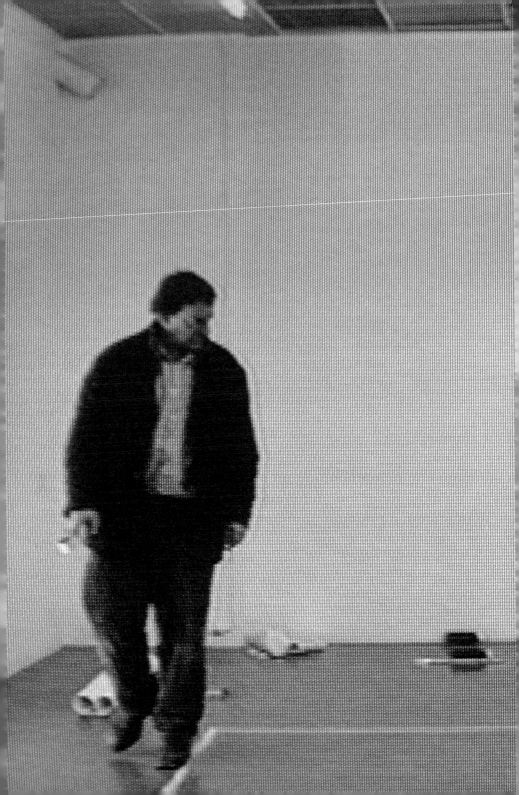

Sigmar Polke
Germany
born 1941, Silesia
(now Poland)

**The Higher Powers
Command: Paint the Right
Hand Corner Black**
1969
Lacquer on canvas
150 x 125 cm
Froehlich Collection,
Stuttgart

This is one of a group of paintings Polke made in the 1960s at the behest of the 'Higher Powers'. Supposedly acting as the agent of forces beyond his control, he painted the upper right-hand corner of the canvas black, paying homage to the idea of painting as the product of other-worldly inspiration. However, the resulting image does not have the look of spiritualized abstract art with a mission to communicate the artist's inner emotions. Instead it mimics American colour-field painting, its minimalism communicating only the flatness of the canvas, its title locking the image and its means of production into a self-referential circularity. The medium is the message is the medium, and Polke's ironic foray into the world of involuntary action confirms his own mastery of it all.

Höhere Wesen befahlen: rechte obere Ecke schwarz
malen!

David Robilliard
England
1952–88

**The Yes No Quality
of Dreams**
1988
Acrylic on canvas
121.9 x 121.9 cm
Collection: Judy Adam,
London
Photograph: Prudence
Cuming
© Estate of the Artist 2000

In this painting, as in his deceptively simple poetry, David Robilliard uses everyday language and accessible imagery to evoke possibilities beyond the ordinary.

Noteworthy
Release your dream
get a drum machine
put a riff
in your terrific
get some brass
and a touch of class
do a bit of social cruising
we have one chance
 to celebrate
life

Unravelled Mind
Unravel your mind
and of course
you will find
unravelled mind

Pinned to the Wind
Castles in the sky
are psychological
 erections
hats off to tall buildings

No Title
when literally nothing
remains of your past
you're part of the cosmos
 at last

All from David Robilliard,
Inevitable, 1984

THE YES NO QUALITY OF DREAMS 1988

DAVID ROBILLIARD

Eva Rothschild
England
born 1971

Black Pyscore Posters
Gouache on poster paper
2 works, 86 x 60 cm
Courtesy the artist

These works are made by painting in a variety of different blacks over brightly-coloured psychedelic posters, submerging the hackneyed imagery of the originals in a world of subtle uncertainty. The artist writes: 'The original images are highly-coloured and computer-led, the elements of fantasy as dictated by the programmes which allow such visualization are conservative and prescriptive. They are also easy to use and so the fantasy image can be produced almost carelessly. They offer unlimited access to surface effects (metallic, fractured, rippled…) and stick close to known components of fantasy imaging (magic mushrooms, floating cities and endless reflections). They are perhaps a sign of interest in a more expansive consciousness but they are a totally known quantity. Their slickness and familiarity cause the viewer to bounce back off the slippy surface and into themselves again. Real fantasy is rooted in desire, fantasy images are about the hardness and realness of desire, they will only truly occur when forced to exist… I wanted to try to take the image closer to its subject, to make the image and the subject merge so that the hard looking that the black gouache forces on the viewer causes a fall forwards to a darker, wider space.'

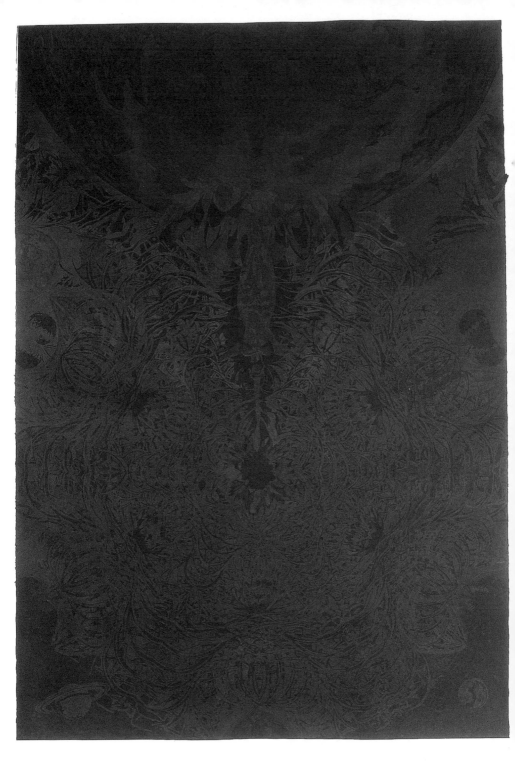

Kurt Schwitters
Germany
1887–1948

**The Primordial Sonata
(Ursonate)**

1922–32
CD recording of original
performance by Kurt
Schwitters, 1926
Running time: 40 minutes,
38 seconds
Illustrated: Photographs of
Kurt Schwitters performing
the *Ursonate*. © DACS, 2000

Of this work, the artist wrote:
'Letters, of course, give only a rather incomplete score of the spoken sonata. As with any printed music, many interpretations are possible. As with any other reading, correct reading requires the use of imagination. The reader himself has to work seriously to become a genuine reader. Thus, it is work rather than questions of mindless criticism which will improve the reader's receptive capacities. The right of criticism is reserved to those who have achieved a full understanding. Listening to the sonata is better than reading it. This is why I like to perform my sonata in public. But since it is not possible to give performances everywhere, I intend to make a gramophone recording of the sonata…'

Fümms bö wö tää zää Uu,
 pögiff, kwiiee.
Dedesnn nn rrrrrr, Ii Ee,
 mpiff tilff toooo? Till,
 Jüü-Kaa.
(sung)

Rinnzekete bee bee nnz
 krr müü? ziuu ennze
 ziuu rinnzkrrmüüüü;
Rakete bee bee.
Rummpff tillff toooo?
Ziiuu ennze ziiuu
 nnskrrmüüü, ziiuu
 ennze ziiuu
 rinnzkrrmüüüü;
Rakete bee bee,
Rakete bee zee.

Fümmsbö wö tää zää Uu,
Uu zee tee wee bee

zee tee wee bee
zee tee wee bee
zee tee wee bee
zee tee wee bee
zee tee wee bee
Fümms…

John Shankie
Scotland
born 1957

Go to Sleep

1995
Steel filing cabinet, file
inserts, notes on paper
70 x 42 x 62 cm
Courtesy the artist
© the artist 1995

A filing cabinet – albeit
one with unusually
labelled drawers –
John Shankie's work has
a prosaic exterior.
However, viewers are
invited to engage with
what is inside the cabinet:
pages and pages of the
involuntary poetry of the
hypnagogic state –
writings made on the
borderlines of
consciousness at a point
somewhere between
waking and sleeping.
The writings are made
every day, on odd scraps
of paper and the backs
of envelopes. They have
a provisional quality,
one in which the form
of the writing seems as
important as the content –
words tumbling out of the
mind and on to the page,
meaning spiraling from
one line to another:

'The last thing written
ever
shot told
caught hold
not cold
I had a lad
Trumbly green
TA ZZ Bus
I go sometimes
I fell from XLS
Why do we jump.'
 The writing, like the
filing cabinet drawers,
makes an appeal for the
active engagement of the
viewer. It demands time
and trust, a recollection
of and projection back into
the familiar state on the
edge of sleep where we
can just – but only just –
direct our thoughts and
dreams.

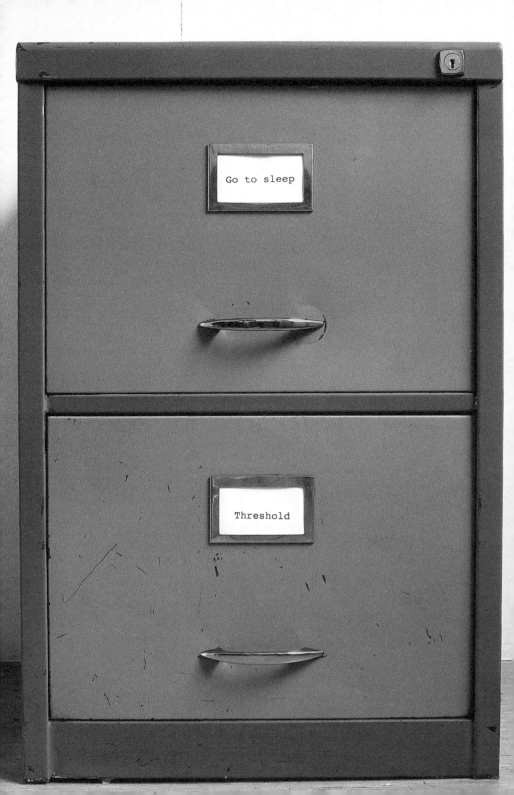

James Turrell
USA
born 1943

Mongo – The Planet
1998
MDF and 9-inch Panasonic
television
Dimensions variable
Courtesy Michael Hue-
Williams Fine Art, London
Image courtesy Galerie
Almine Rech, Paris
© James Turrell, courtesy
Michael Hue-Williams
Fine Art

James Turrell's *Mongo – The Planet* glows with an intense other-worldly light. Television-like in shape and scale and therefore somewhat familiar, it seems nevertheless alien and unsettling. Uncertain whether it is a solid surface or a pigmented void, the viewer approaches with caution. Close-up, the work reveals itself as an opening on to a void lit from within by a shifting light. Confirming and subverting the work's initial appearance, the light comes from an unseen television lying on its back. In the space lit by the television there are no spatial clues, nothing for the eye to rest on and no way of understanding space or depth. The eye moves forwards into the space and backwards towards the shape on the wall, giving rise to an irresistible urge to reach out and hold the light. The unearthly glow of the light works against our knowledge of televisions as programmable objects of domestic hardware, admitting a sense of communication from beyond, of images in the ether.

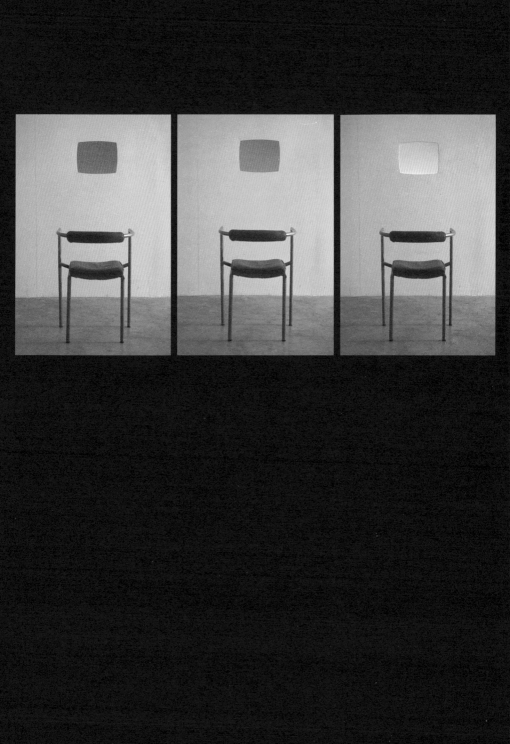

Keith Tyson
England
born 1969

**Artmachine Iteration
No. AMCHII-LX, Untitled**
(response to a telepathic
request for collaboration)
1995
Canvas on frame
117.6 x 117.6 x 4.9 cm
Private collection
Courtesy Anthony Reynolds
Gallery, London
Photograph: Mike Fear

Telepathy is the ability to sense another person's thoughts and feelings, or to convey your own to other people without the use of speech, gesture or other physical signaling. Keith Tyson's painting represents the results of an invitation he issued telepathically, asking for collaborators to work with him. Either the artist's telepathic sending or the potential collaborators' receiving seems to have failed since apparently there were no replies. Tyson exhibits a blank stretched canvas as the result of this experiment, indicating that responses were not forthcoming. The title of the work reveals that it was executed in accordance with a proposal made by Tyson's *Artmachine*, a complex step-by-step computational rule designed to generate ideas for an infinite number of artworks. The machine monitors every manifestation of recorded human thought – libraries, dictionaries, encyclopaedias, the internet – and makes decisions about the subject and form of the proposed work. The artist decodes the machine's specifications, and then realizes the resulting artwork or 'iterations'.

Jane and Louise Wilson
England
born 1967

Routes 1 and 9 North
1994
Single-screen video
Running time: 10 minutes
Courtesy Lisson Gallery,
London
Photograph: Mike Fear
© the artists and the Lisson
Gallery 2000

This video work invites us to watch twins Jane and Louise Wilson being hypnotized in a seedy American motel room. The two artists present themselves as guinea-pigs in a potentially mind-altering experiment. The camera's gaze is unflinchingly directed at them, inviting us to observe their progress towards entranced acquiescence with the hypnotist's instructions. For most of the work's real-time duration, we watch the artists co-operate with the hypnotist and with each other as they follow instructions, all independent thought suspended, every action documented by the camera's objectivity. The viewer's attitude initially may be impartial, distanced, sceptical or voyeuristic but this separation can easily shift into participation, since the hypnotist's opening efforts to relax the artists may also affect viewers, who, as they listen and watch, may find their own breathing slowing, their bodies relaxing and their attention deepening as they become absorbed in the work.

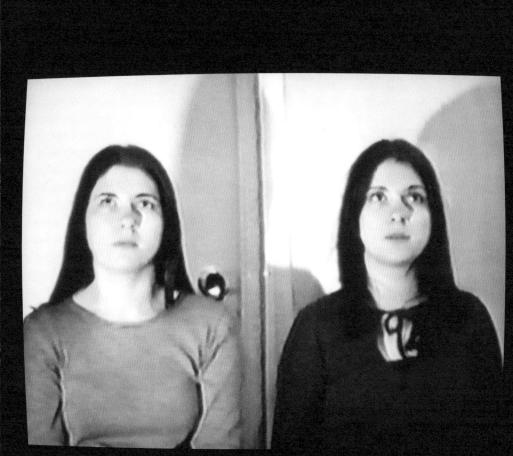

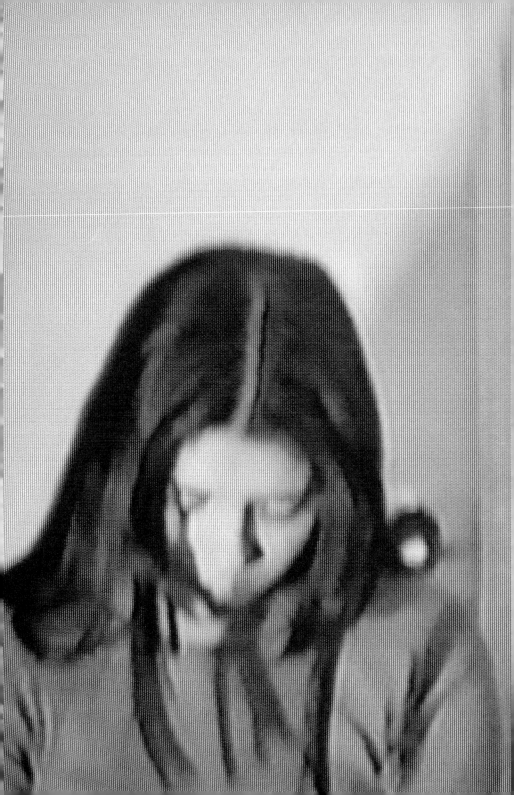

Jean
Fisher

Truth's
Shadows

Borges' magician aspires to dream a man. 'He wanted to dream him in minute entirety and impose him on reality.' And so, over a 'thousand and one secret nights', beginning with the heart, and 'entrail by entrail, feature by feature', the magician conjures his simulacrum and sends him out into the world as if he were real, only to realize that his own reality is in question.

What enchants us in Borges' tale is the question it poses about the life of the imagination, the well-spring of both dreaming and the making of art. In these circular ruins, the autonomous subject of knowledge loses ground; indeed, the logic of time and space falters in the magician's oneiric awakening. It is tempting for the anglophone West to interpret the author's game of infinite displacement between reality and dream as the expression of a trauma born of the ambivalent, anthropophagic relation between Latin American and European modernity. And yet, Latin American writers saw in advance that an awareness of its own ungroundedness has dwelt uneasily on the borders of Western consciousness throughout the twentieth century, even if it was finally given a somewhat belated discursive voice during the 1980s.

I am referring here to what was then described as a loss of distinction between the real and the imaginary, to the point where, 'each dissolves into an empty imitation of the other'. If this is so, Richard Kearney asks, 'can we still speak of imagination at all?' and along with it, a 'philosophy of truth'.[2] It has often been said that we in the West are so entangled in the webs of mediated realities that we can no longer distinguish referential from simulated modes of experience because both are perceived as 'real'. 'Reality,' as Jean-Jacques Lecercle laconically remarked, 'is what my desire fabricates',[3] a statement which opens on to the psychoanalytic assertion

1
Jorge Luis Borges, 'Las ruinas circulares,' in Narraciones, Madrid: Catedra, 1990, pp. 97–103; English edition: 'The Circular Ruins,' in Fictions, London: Calder and Boyars, 1974, pp. 52–58
2
Richard Kearney, The Wake of Imagination, London: Hutchinson, 1988, p. 359
3
Jean-Jacques Lecercle, Philosophy through the Looking Glass, La Salle, Illinois: Open Court, 1985, p. 180

that desire is always that of the Other, subject of the disciplinary codes of Oedipal constraint: Is 'my' desire ever mine, does it trace out my inner longings, or is it not precisely the imagistic-imaginary seduction of consumerism that traps and absorbs my libidinal drives to feed the insatiable appetite of its vampiric machine? Has the image industry colonized our psychic worlds as thoroughly as the physical world so that, like Borges' magician, we are always dreaming someone else's dream, playing out someone else's phantasy? If the structure and content of dreams – a veritable playground of desire – are conditioned by the realities that society imposes on us, then can we still speak of the imagination as a form of individuated experience – imagination being identified here as the ability to conjure images of absent or non-existing objects through phantasy, hallucination or artistic processes? But perhaps, more crucially, can we still speak of the ability to imagine other realities and the possibility of transforming human existence? Italo Calvino poses the problem in this way:

'Will the power of evoking images of things that are *not there* continue to develop in a human race increasingly inundated by a flood of prefabricated images? At one time the visual memory of an individual was limited to the heritage of his direct experiences and to a restricted repertory of images reflected in culture. The possibility of giving form to personal myths arose from the way in which the fragments of this memory came together in unexpected and evocative combinations... [We are in danger of losing] the power of bringing visions into focus with our eyes shut, of bringing forth forms and colors from the lines of black letters on a white page, and in fact of *thinking* in terms of images.'[4]

...like jetsam on the surface of a dead sea
André Breton

We might ask what is new in this, since when have humans not lived in the matrix of language and the fictions of reality that

4

Italo Calvino, *Six Memos for the Next Millennium*, trans. Patrick Creagh, London: Jonathan Cape, 1992, p. 92

society manufactures with it? But we have the troubling sense that an irreversible qualitative shift – a 'waning of affect' as Fredric Jameson described it – has taken place in how we experience our realities compared with earlier times, where 'experience' is no longer the knowledge of a life remembered but disembodied information.

Among the paradoxical legacies of Enlightenment rationality has been the failure of its grand narratives of emancipation and progress, where the capitalist system continues to destabilize the structure of communities producing populations deprived of basic human rights. Judging as irrational and irrelevant all that fell outside of its powers of interpretation, the rationalist and pragmatic ordering of the world devalued 'other' knowledges and experiences, including the status of phantasy – dream and reverie – and occult practices as forms of *knowledge*. Thus, for almost 300 years, we have been conditioned to discard as 'shameful' a significant part of what constitutes human experience: the senses, visions, phantasy, passion, child's play, ecstasy, language-beside-itself, in short, all that nurtures and gives form to the imagination. Under rationalism, the inventions of phantasy and imagination were relegated to the domains of the artist, the maverick philosopher, the child and the madman. As the poet André Breton observed in his first *Surrealist Manifesto* of 1924:

'To reduce the imagination to a state of slavery – even though it would mean the elimination of what is commonly called happiness – is to betray all sense of absolute justice within oneself. Imagination alone offers me some intimation of what *can be*… We are still living under the reign of logic… the absolute rationalism that is still in vogue allows us to consider only facts relating directly to our experience… It is pointless to add that experience itself has found itself increasingly circumscribed. It paces back and forth in a cage from which it is more and more difficult to make it emerge. It too leans for support on what is most immediately expedient, and it is protected by the sentinels of common sense.'[5]

5
André Breton, *Manifestoes of Surrealism*, trans. Richard Seaver and Helen R. Lane, Ann Arbor Paperback, University of Michigan, 1972, p. 4/5

Breton was deeply influenced by Freud's work on the unconscious, recognizing within it the discarded territory that needed to be reclaimed from the bourgeois 'sentinels of common sense'. In an analysis of the term 'discarded', meaning both 'rendered useless' and 'deviant', Stella Santacatterina identifies a spatiotemporal dimension.[6] As a spatial metaphor it alludes to the abjected, 'irrational' left-overs of codified knowledge, but at the same time this space of the discarded can be measured and given form. As Santacatterina points out, psychoanalysis was born when Freud drew our attention to the fact that psychical events like neurotic symptoms, phantasy, lapsus and child's play, classified as deviant or insignificant by rationality, are indices of a deep truth, carrying meaning and intention; and from this disavowed and voided space it was possible to construct a narrative knowledge that was both retrospective and anticipatory, that touched upon the hitherto unthought and unthinkable. It is from this territory that Freud draws the analogy between child's play and the creative process, both of which, unlike neurotic phantasy, can clearly distinguish illusion and 'reality'. For Freud, the poet was capable of returning from the phantasmic journey bringing with him – or her – the fruits of his/her discoveries. And the poetic art was seductive precisely because it offered us a 'fore-pleasure': it produced a metalinguistic machine, much like Duchamp's *Large Glass*, that announced a pleasure in the deferral of desire's satisfaction, a mechanism by which, as Freud says, 'we can enjoy our own day-dreams without reproach or shame'.[7]

Dream itself is a repository of the discarded – the traces and fragments of memory, of the 'day's residues' and unfulfilled wishes – and in this sense finds companionship with the impulses of the artistic avant-garde. Moreover, both dream and art have the capacity to abolish the rational disposition of time and space, such that the remote and the nearby constantly collide in an apparent immediacy of affect. For Santacatterina the concept of the discarded is crucial for an understanding

6
Stella Santacatterina, 'Knowledge and the Discarded', lecture, first delivered Rome, 1989

7
Sigmund Freud, 'Relation of the Poet to Day-dreaming', in *Character and Culture*, New York: Collier Books, 1963, p.43

of the status of the artistic object in our time. The object becomes an ambivalent trace of linear time in technological civilization, caught between the rituals of elimination and purification from contamination by the past and those that seek to rescue the past from disappearance. Hence the compulsion to put everything into the archive or museum, a drive that is restaged in twentieth-century art's persistent reclamation and recycling of the discarded object. It is a poetic procedure that Lévi-Strauss named *bricolage* – the putting together and putting back into circulation of discarded fragments into a new formal universe such that the casual takes on the intensity of necessity.

Breton echoes this tactic of the *bricoleur* – or perhaps 'collector' – in a late evaluation of surrealism: 'What was it all about then? Nothing less than the rediscovery of the secret of a language whose elements would then cease to float like jetsam on the surface of a dead sea.' Surrealism saw in the poetic 'image' the means of obtaining 'certain incandescent flashes linking two elements of reality belonging to categories that are so far removed from each other that reason would fail to connect them and that require a momentary suspension of the critical attitude in order for them to be brought together'.[8] This de-familiarization of conventional reference recognizes the fundamental ambiguity of language; where meaning is structured through a chain of resemblances and differences, a word can never truly grasp its object. Exemplary in this respect is Magritte's formal play with the incongruity of word and image, familiar from books of popular knowledge on the interpretation of dreams and, as Freud pointed out, characteristic of the operations of oneiric language. Magritte's work was heavily indebted, not to the surrealist project *per se*, but to the 'metaphysics' of Giorgio de Chirico, whose work was likewise concerned with the repressed 'other' of formalized language – in his case, through displacing the apparent logic of Renaissance spatiotemporal perspectivalism. For both artists it was not a question of illustrating subjective (imaginary)

8 Breton, 'On Surrealism in its Living Works,' [1953] in *Manifestoes*, op. cit., pp. 297, 302

points of view (the limitation of the surrealist project as it was broadly expressed) but of revealing the enigmatic event of the objective world itself.

Nevertheless, as Breton envisioned, from the discarded and the obsolescent of both dream and civilization, in the 'disinterested play of thought' (his 'psychic automatism'), in the *bricoleur*'s play with the predictable and the unpredictable, is born a new and different vision of the world, antithetical to the 'truth' of rationality and linked only to the power of its own 'truth' or knowledge.

There is no meaning without some dark spot, without some forbidden/impenetrable domain into which we project fantasies which guarantee our horizon of meaning.[9]
Slavoj Žižek

To abandon the quest for an 'ultimate truth' governed by the light of reason is to open up a 'forbidden' space of knowledge, where we encounter other times and other cultures, whose concepts of the relative truths of reality and dream are far from unsophisticated, weaving richly textured narratives that make our own imaginations seem singularly impoverished and one-dimensional. For instance, most shamanic cultures believe that therapeutic powers achieve their efficacy only through oneiric learning. Likewise, in the passage of the initiate through the Eleusian mysteries of Greek antiquity, the highest knowledge was considered to be visionary and dreamlike. Graeco-Roman antiquity shared with mediaeval thought a rich lexicon of affects, amongst which we find that the dream connected the realms of man and the divine or the daemonic, not as the property of the dreamer but as a message from divine sources that had a collective application; but above all that the dream could be used as an instrument of healing and divination – not in the popular sense of 'predicting' the future but of understanding how prevailing conditions may influence the course of future events. Dreams, according to the classical

9 Slavoj Žižek, *The Plague of Fantasies*, London and New York: Verso, 1997, p. 160

drama of Euripides, were 'truth's shadows upfloating from earth's dark womb', which in the night 'should be oracular to men, foretelling truth'.[10] Coxhead and Hiller succinctly describe how very exhaustive antique investigation of dream imagery and interpretation was: 'During the seven hundred years between Heraclitus and Artemidorus, the second century AD oneirologist, we can trace all the theories of dreaming – materialist, mystical, analytical, occult and medical – that were available to the west at the beginning of this century.'[11]

Far from representing a superstitious mindset, late antique oneiric discourses were, as Patricia Cox Miller emphasizes, 'one of the modes of production of meaning': 'Dreams formed a distinctive pattern of imagination which brought visual presence and tangibility to such abstract concepts as time, cosmic history, the soul, and the identity of one's self. Dreams were tropes that allowed the world – including the world of human character and relationship – to be represented.'[12] As Giorgio Agamben also points out: 'for Antiquity the imagination was the supreme medium of knowledge… As the intermediary between the senses and the intellect, enabling, in phantasy, the union between the sensible form and the potential intellect, it occupies in ancient and medieval culture exactly the same role that our culture assigns to experience.'[13]

But Agamben goes on to point out that a seemingly irreversible sea-change took place with the birth of modern science, which expunged the phantasmic imagination from knowledge as 'unreal', whereupon it lost its mediating role. 'From having been the subject of experience the phantasm becomes the subject of mental alienation, visions and magical phenomena – in other words, everything that is excluded by real experience.'[14] It is here that Agamben provides us with another dimension to the problem of the discarded, for the removal of imagination from the realm of experience 'casts the shadow of desire'. In excluding imagination from experience and replacing it by the Cartesian subject, which knows itself only through the suppression of its desired other, imagination

10
Quoted in Patricia Cox Miller, *Dreams in Late Antiquity: Studies in the Imagination of a Culture*, New Jersey: Princeton University Press, 1994, p. 21

11
David Coxhead and Susan Hiller, *Dreams: Visions of the Night*, London: Thames and Hudson, 1976, p. 5

12
Cox Miller, op. cit., p. 3

13
Giorgio Agamben, *Infancy and History: Essays on the Destruction of Experience*, trans. Liz Heron, London and New York: Verso, 1993, p. 24

14
ibid., p. 25

comes to figure the inexperiencibility of the other. For experience to reunite with the flux of desire, therefore, the ego must somehow relinquish control of 'reality' and the self surrender itself to the unknown – to undergo an 'eclipse of thought'. But how might this be visualized?

Federico Fellini set about writing the screenplay for *8½* in a desperate effort to break a creative block, and a director's search for inspiration is the 'autobiographical' motivation for the film's narrative. In the dreamlike opening sequences, the protagonist, trapped in his car in a traffic jam, experiences an attack of suffocation. Clambering out of the car window, he (his imagination) bodily 'takes flight' like a kite, then goes into free fall. An analogous experience, precipitated by the 'flicker effect' of sunlight through trees passed on a bus journey, is recounted by Brion Gysin, and was to inspire the *Dreamachine*: 'An overwhelming flood of intense colors exploded behind my eyelids: a multi-dimensional kaleidoscope whirling out through space. I was swept out of time. I was out in a world of infinite number…'[15] Or again, Henri Michaux's reflections on drawing under the 'flashback' effect of mescaline: '…called [to take up the pen] by a slight dizziness that makes the light lines feel shaky as well as the space they create, I find myself […] once again into a familiar fleeting world, immense and immensely pierced, where everything at the same time is and is not, shows and does not show…'[16] These scenarios recount a 'dizzying' fall out of rational space-time, and coincide rather beautifully with what Catherine Clément identifies as 'syncope' – a momentary loss of breath, a blackout, an ecstatic insight, eclipse of thought, an off-beat that introduces dissonance into a rhythmic flow. Syncope's effect is a suspension of time and consciousness, which both effects and anticipates a shift towards 'inspiration', or imaginative invention. Syncope is an affect that 'strips thought of its weapons', taking the risk of a 'temporary disappearance of identity', and is therefore 'on the side of the fragmentary, of hesitation, of risk'.[17]

15
Brion Gysin, 'Dream Machine', *Olympia*, Paris, No. 2, 1962

16
Henri Michaux, quoted in Jean-Jacques Lebel, *Henri Michaux: Dibuixos mescalínicas/Dibujos mescalínicos*, Barcelona: Centre Cultural Tecla Sala, 1998, p. 155

17
Catherine Clément, *Syncope: The Philosophy of Rapture*, trans. Sally O'Driscoll and Deirdre M. Mahoney, Minneapolis: Minnesota University Press, 1994, pp. 164/165

The imagination is a kind of electronic machine that takes account of all possible combinations [of images] and chooses the ones that are appropriate to a particular purpose, or are simply the most interesting, pleasing, or amusing.[18]
Italo Calvino

Within the spectrum of artistic procedures that are directly concerned with art as a language of the imagination, we can cite those inspired by internal syncopated experiences; those that engineer analogous experiences in the relationship of work and viewer; and those that explore oneiric or occult territories, albeit with some scepticism. Given my own interest in how the relationship between work and viewer 'works', I should like to attend to those strategies that are consciously concerned with mobilizing 'imagination', bringing into play the role of the 'machine'.

The phantasmic machine as a device for releasing the libidinal drives to the play of the imagination has proliferated from the modernist period to the present. Among some of its literary and artistic expressions are Alfred Jarry's perpetual motion machine in *Supermale*; Franz Kafka's tattooing machine that performs as it writes the death sentence on the body of the condemned prisoner in *The Penal Colony*; Raymond Roussel's elaborate language-machine for the production of *Impressions d'Afrique*; Marcel Duchamp's *Bicycle Wheel* (a virtual perpetual motion machine), *Fountain* (a virtual flow machine) and *Large Glass* (an orgasmic delay machine); Kurt Schwitters' recorded *Primordial Sonata*; Bioy Casares' projection machine in *The Invention of Morel*; Brion Gysin and Ian Sommerville's *Dreamachine*; Gustav Metzger's *Liquid Crystal Projections*; James Turrell's *Mongo – The Planet*; Susan Hiller's *Belshazzar's Feast*, *Magic Lantern* and *Dream Screens*; Deleuze and Guattari's 'desiring machines'; and the most powerful dream machine of the twentieth century, the cinematic apparatus itself, to which the artistic imagination of our time constantly refers. 'Deep down,'

Calvino, op. cit., p. 91

Michaux confessed, 'I appreciate cinema more than painting.'[19]

Like Michaux, Casares recognized the cinematic apparatus as a hallucinatory machine that unveils an essential undecidability of space and time, reality and imagination, and his novella, *The Invention of Morel*[20] both encapsulates the ambiguous position of the desiring viewing subject and 'foretells' the subject-to-come of the cyber-machine. A man, stranded on an island finds an abandoned museum containing numerous machines. He begins to hear voices, to see people, one of whom, Faustine, he falls in love with; but his own presence is mysteriously ignored. Is he dreaming, hallucinating, mad, or the witness to a virtual reality machine that has recorded characters long since dead? Overcome with desire for Faustine, he plans to stage his own death and 'unite' with her by re-recording the scenes and suturing himself into (we might now say, 'by interfacing with') the phantasmatic projection. It is as this 'disaggregated' bio-machine that Casares' protagonist connects to the subject of post-modern time-space.

The phantasmic machine articulates the limits of an instrumental use of language, expressing a libidinal economy not contained by the mechanistic machine. As Jean-Jacques Lecercle says, this machine produces effects: flows of energy, of matter, of body fluids, of phantasies... and to produce effects is to be in a state of becoming.[21] A becoming is not a structure, which is something that has arrived at a representation and a subject and therefore posits a finite meaning. On the contrary, like the syncope, becoming is a moment in which the 'language of rationality dissolves in the language of expression': conventional meanings are disrupted, opening language to the frontier between the known and unknown, sense and non-sense. Thus, with the uncoupling of language from rational and Oedipal constraints, a free flow of desire is produced, escaping along what Deleuze and Guattari call *lignes de fuite* (lines of flight) inscribed across an imaginary 'body without organs', a 'desiring machine' that couples rhizomatically with the

19
Michaux, in Lebel, op. cit., p.152

20
Adolfo Bioy Casares, *La invención de Morel* [1941], Madrid: Catedra Letras Hispánicas, 1998. Casares was a close friend of fellow Argentinian Borges. The novella was the inspiration for *Last Year at Marienbad* (dir. Renais and Robbe-Grillet, 1961)

21
Lecercle, op. cit., p.173

fragmented and fragmentary. This is the loss of fixity and disaggregation that Michaux had already described for the accelerated experience of mescaline: 'Where previously there was fixity, here there was nothing more than flux, flux coursing indifferently through the hardest and most flexible of things, flux like those cosmic particles that go right through the earth…'[22] And the flux of detached desire arouses the play of phantasy.

This play is central to the experience of Susan Hiller's work and is characteristically coupled to the artist's concern with agency: that is, with expanding the viewer's consciousness of the 'enigma' of the world beyond coded appearances. Exemplary in this respect is the audio-visual projection *Magic Lantern* (1987), a machine for inducing syncope's hallucinatory state of reverie, and comparable to Gysin and Sommerville's *Dreamachine*. *Magic Lantern* refers to other machines: to the early projection devices of the nineteenth century, which were used not only in scientific discourses on vision and perception but also in the production of 'apparitions' for mediumistic popular entertainment; and to the cinematic apparatus, in which the projector, sited behind the viewer's head, produces images that appear to flow from the viewer's own consciousness. But the work also prefigures our relationship to the computer interface, which is the medium Hiller uses in *Dream Screens* (1996), a work designed specifically to trap the wandering imagination of late night Web surfers. This is a complex work, which draws on a number of discourses, including those of painting, psychoanalysis and popular cinema. The user enters through a web-shaped colour palette where she can then choose to click into one of a large range of colour fields. At the same time, she can choose from a selection of languages and listen to short narrations, like recollected dreams, interspersed with pulsar signals and heartbeats – the juxtaposition of near and far. The model is the labyrinthine game of infinite couplings and flows, the shift from structure (the finite) to the event (the indefinite), which

Michaux, in Lebel, op. cit., p. 152

is the nature of cyberspace itself.

I began this essay by introducing the notion of a crisis of imagination for the post-modern subject, who is bombarded with prefabricated signs and meanings but bereft of a coherent set of universal principles for interpretation or action. If the Web is a compelling model for this experience of everyday reality it is because, as Žižek suggests, the workings of the machine are now opaque, hidden behind the interface, providing no clear co-ordinates, and in relation to which the lone subject must 'find his bearings'.[23] Abandoning the referential/simulated distinction, self-mapping is the final solution open to Casares' protagonist who encodes himself into the image flow of virtual reality; and of the *bricoleuse*, who selects from fragments of the system those she can use to mobilize her own 'regime of truth'. But how far is the subject in cyberspace now itself fragmented, disaggregated into particulate selves dispersed in the encoded intelligence of the bio-machine? Will this new machine return us to a state in which our dreams and phantasies can be used to inform and structure the dimensions of our own life-worlds; or will it so erase individual historical memory that we become like the humans in the film *The Matrix* (1999).[24] As authors here have said, it is necessary to return from the phantasmic journey in order to put the creative insight to use. But will we be able to awaken from the electronic opiates of the virtual reality machine? It is too soon to say. In the end it is, perhaps, the role of artistic endeavour not to lose sight of that impenetrable 'dark spot' within the mechanism which gives us our horizon of meaning; to explore ceaselessly both the limit and the extension of our imagination.

23
Žižek, op. cit., p.130

24
The film takes an extremely dystopic view; having broken through the computer interface, the heroes discover that reality is completely virtual and that humans exist only to feed the need and desire of the machine.

Exhibition selected by
Susan Hiller
Exhibition organised by
Fiona Bradley, assisted
by Sophie Allen

Catalogue designed by
Esterson Lackersteen
Printed by The Good
News Press

Front cover: Brion Gysin
& Ian Somerville,
Dreamachine, 1960
Opening image: Lygia Clark,
Baba antropofágica, 1973
Closing image: Jim Lambie,
ZOBOP, Transmission
Gallery, Glasgow, 1999

Published by Hayward
Gallery Publishing,
London SE1 8XX
© The South Bank
Centre 2000
Texts © the authors 2000
Artworks © the artists 2000,
unless stated otherwise

The publisher has made
every effort to contact all
copyright holders. If proper
acknowledgement has not
been made, we ask
copyright holders to contact
the publisher

ISBN 1 85332 202 4

This publication is
distributed in North and
South America and Canada
by the University of
California Press, 2120
Berkeley Way, Berkeley,
California 94720

Hayward Gallery Publishing
titles are distributed outside
North and South America
and Canada by Cornerhouse
Publications, 70 Oxford
Street, Manchester M1 5NH
Telephone 0161 200 1503
Facsimile 0161 237 1504